A YEAR BETWEEN FRIENDS

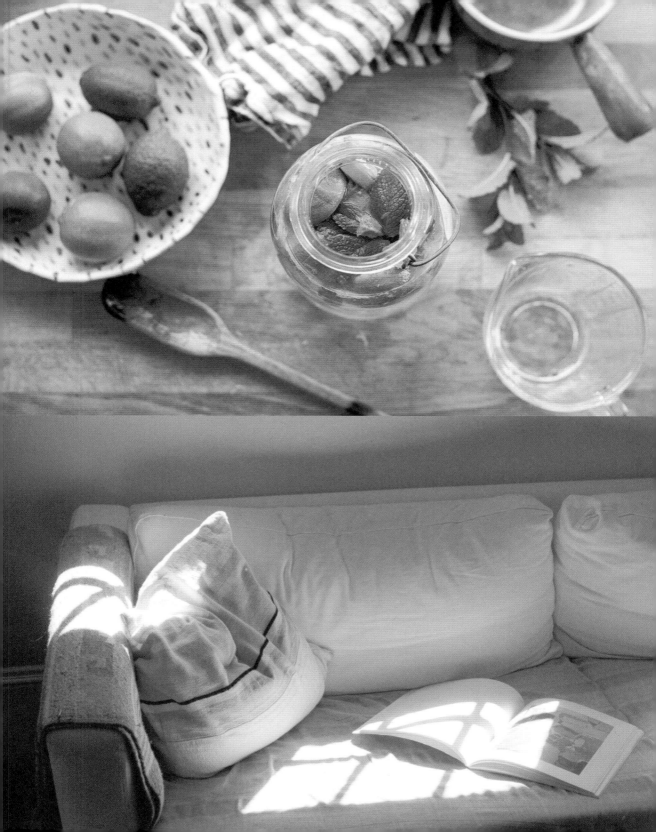

A Year Between Friends

3191 MILES APART

CRAFTS, RECIPES, LETTERS, AND STORIES

MARIA ALEXANDRA VETTESE AND STEPHANIE CONGDON BARNES

ABRAMS / NEW YORK

For Mia and Miles.
Carry this with you.

—SCB

For my mom, Christine.
You loved me deeply, you told me often
and for that, and much more, I am
forever grateful.

—MAV

CONTENTS

FOREWORD

Molly Wizenberg

I've been waiting for this book for ten years, a very long time. Actually, I've been waiting, whether I knew it or not, for longer than that—since late 2005, when I first came across a blog called port2port and one of its authors, who went by the initials MAV. I was new to blogs then, as we all were, but right away, I was drawn to the humble eloquence of Maria's words and the photographs she posted. There was something special about her, and I knew it for certain when, after exchanging only a couple of emails about our respective blogs, Maria surprised me with a gift, sent to my apartment in Seattle all the way from hers in Portland, Maine. Inside was a bottle of local maple syrup, wrapped in a soft linen tea towel and bundled with striped cotton twine, and a postcard written in her strong, looping script. It was only the first of many things, both tangible and intangible, that Maria would give me through her friendship, her art, and the way she sees the world.

Around the time that I "met" Maria, I also joined a little photo-sharing website called Flickr, and there I first stumbled upon the work of Stephanie Congdon Barnes. Stephanie, who lived in nearby Portland, Oregon, was not only a gifted photographer and the mother of two young children, but she could also make with a needle and thread things I couldn't even dream of: hand-sewn pinecones of carefully layered wool and silk, or whimsical stuffed bunnies so full of character, you'd half-expect them to talk. At the time, I didn't know that I even cared about handmade objects—I didn't know how to sew and wasn't interested in learning—but Stephanie's artistry, the care she invested in her work and her life, thrilled me in a way that I couldn't explain. It woke me up.

Maria was active on Flickr, too, and like me, she was a fan of Stephanie's work. There was something new happening online, something big, and the three of us were just a small part of it: an exchange of photographs and inspiration, an excited murmuring among a community of people who cared about art, about making things

by hand, about the inherent beauty and value in ordinary objects and ordinary life. It was in the caption to one of Maria's Flickr posts that I first heard expressed the idea that everyday life is art. And that idea, though so straightforward, so obvious on the surface, changed everything for me.

3191 Miles Apart was born on Flickr, one December morning in 2006 when Maria and Stephanie each separately posted a photograph that, without any intention or planning, somehow echoed the other. I remember seeing the photos that day and being struck by the similarity in their sensibilities. Stephanie and Maria decided, on the basis of those two photographs, to start a formal collaboration, a yearlong conversation with each other. Each day, from their homes 3191 miles apart, they would post a photograph taken that morning. The project was beautiful, a quiet and thrumming kind of beautiful, and it was also intimate, a privileged glimpse into another's private world. I looked forward to it every day, and so did the thousands of others who followed the project, watching from afar the friendship that unfolded between the two artists.

And when the year was over, much to our luck, Maria and Stephanie didn't stop. Instead, they began a new year of photographs, now taken each evening; then two books of photographs; then a quarterly publication filled with more photographs, recipes, writings, and ideas for handmade projects; and now the book in your hands, the result of a decade of inspired collaboration. It is everything I could have hoped for: warm, generous, and, of course, visually stunning. It is also practical, crammed with good ideas and project tutorials, from Stephanie's pinecones and bunnies (yes!) to sun-print napkins; recipes for soups, scones, Maria's mother's sugar cookies, and more; and simple getaway ideas for Maine and Oregon. Most of all, it's the record of a friendship between two women, both devoted to the art of everyday life, even as they and their families grow and change through great loss and great love.

"The work we were doing," Stephanie observes, "was essential to surviving what life set before us." The work of 3191 Miles Apart has been essential to so many of us. I hope it's only the beginning.

Maria Alexandra Vettese

MAV

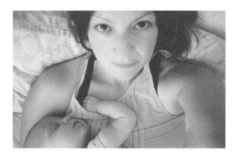

Portland, Maine

Stephanie Congdon Barnes

S C B

Portland, Oregon

One never knows what will happen over the course of a year. Most of us mark New Year's Eve thinking, I hope this year is better than the last or I wonder if this year will top the last, and then we just dive in! We have no other choice. When Stephanie and I decided to document a full year for this unique book, I assumed we knew what the process would be like. We had done it before in our previous books, *A Year of Mornings* and *3191: Evenings*. What could be so different? Well, our year between friends here ended up being quite different, and I am taking away so many deeply personal lessons and remembrances from it.

Unlike our previous web projects and books, this time we decided to share not just intimate film photographs taken in the moment, but words and actual events as well. We share heartfelt stories, nostalgic recipes, iconic projects, and our monthly correspondence by letter. It would have been easier to just share the photographs but this time around, we wanted to give more.

This year has been one of the hardest and most memorable of my life. I leave it behind, remembering how much I was supported and sustained by my dearest friends and family, which of course includes my friend of ten years, Stephanie (known here by her initials, SCB), and how much I was braced by documenting my life in this book of memories.

Thank you, readers, for sharing this year between friends with us. I am grateful to each of you.

MAV

When I met Maria (who I came to refer to by her initials: MAV) ten years ago on a photo-sharing website, photographing your morning coffee had yet to become a social media norm. We found an immediate connection through our appreciation for and documentation of our everyday surroundings (including, yes, our coffee cups). Curious about each other's lives, but separated by 3191 miles, we forged a friendship through collaboration, posting our images side by side, near daily. Over the years, our communication has grown to include daily texts and emails, long phone calls, handwritten notes, and yearly in-person visits, but our primary connection remains the images we capture with our cameras.

This year, when MAV's life was punctuated by extremes of heartbreak and joy, often the images spoke more clearly and eloquently than words ever could, and I was grateful to be able to pick up my camera. At the onset of this book's creation, I worried about balancing the documentation of everyday beauty with the nitty-gritty of career, relationships, and family. I found, however, that my camera's focus—on the busy work of making things, the nourishment of favorite meals, and the rhythm and routine of my days—was exactly what sustained me, despite the inevitable messy or difficult moments.

While MAV has just begun motherhood, I am the parent of two teens who are only a couple of years away from leaving home; sometimes it seems they already have one foot out the door. Our gatherings and traditions have become more poignant as my children edge toward adulthood. I realize now that I've created this document of our lives together as a family that they can literally carry with them when they leave.

Readers, I hope you will carry it with you as well, or share it with your own faraway friends, or be inspired to document your own life in this way.

SCB

JANUARY

DEAR MAV,

Happy New Year!

Maybe I sound unsentimental, but come January 1, I am happy
to put away the holiday décor and dispense with the scraps
of gift wrap and ribbon that litter the house—the tins of stale
gingerbread cookies, the off-the-mark holiday gifts. The lovely,
magical clutter and busyness of this past December gave
way to the quiet and order of January. Mia and Miles returned
to school after their winter break, and I returned to work
with a renewed earnestness and dedication, full of ambition
about what I will accomplish this year. I have been busy and
organized around the house as well—mending and stitching,
filling my freezer with soups and stews, cleaning out drawers
and the dark recesses of my closet.

 I think of you often, negotiating the snow and ice, 3191
miles away. I worry about you. I wish that I could show up at
your door with a steaming pot of soup. I looked at the weather
forecast for Maine the other day and realized that I can't
even fathom what minus 9 degrees feels like. We have had
the mellowest of winters here in Oregon. Gray, yes, but mild
and mostly dry. We went up the mountain in hope of a snowy
adventure, but had to settle for a woodsy early spring. I even
saw a trillium blooming!

 XO,

 SCB

DEAR SCB!

I brought in the New Year with good friends at The Jewel Box,
a small cocktail bar here in town. I want to take you there the
next time you visit. I felt giddy because of the news that many
at the gathering did not know yet, but of course you did. What
an incredible way to start the year! As I write this I am now over
15 weeks pregnant. So surreal. I have been waiting four years so
I feel very lucky to be where I am. I won't forget this feeling.

I am always excited about January because of the
newness, but I certainly haven't gotten as much done this
month as I would have liked. I do like starting things fresh
though and feel it gives me more motivation. I was definitely
ready to leave last year behind and have a feeling this year is
going to be really good. I also feel a sense of nervousness, but
I'm not sure why. I don't think it has to do with being pregnant
and it might be more about turning 40. Who knows? You have
done the early 40s so far with such grace and ease. I have a
good role model.

I think our winter is going to be a zinger and I worry
about being able to keep warm. My acupuncturist says warmth
is critical to feeling well in the winter, not to mention caring for
the growing baby, so I am on the search for some good wool
leggings. Let me know if you find some. Here we go, new year!

ALL MY LOVE,

MAV

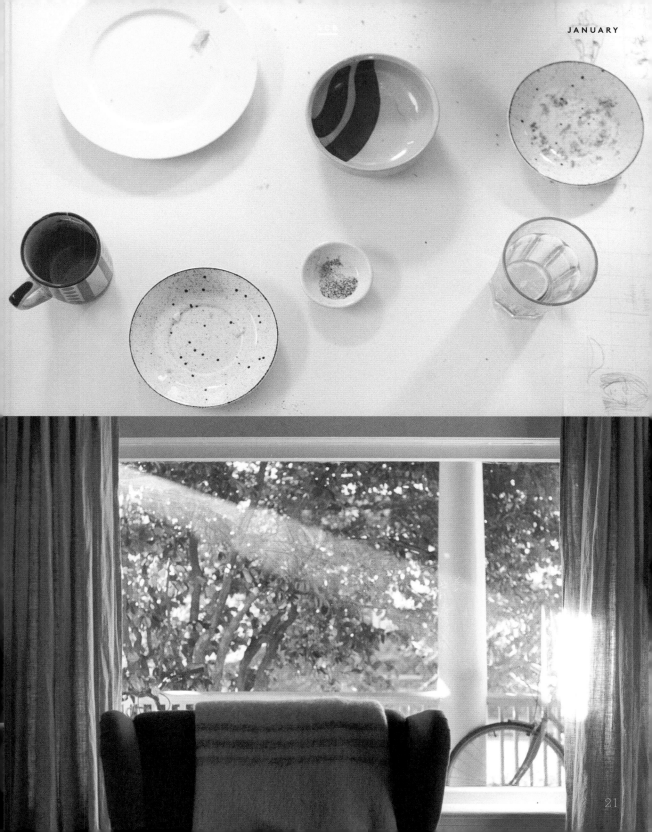

Buttermilk Scones

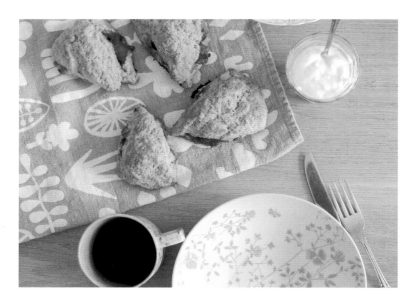

I started the new year with these beautiful, buttery scones. Such a tasty way to celebrate a new beginning! **MAKES 8 SCONES**

1 cup (125 g) all-purpose flour,
 plus more for shaping the scones
1 cup (120 g) whole-wheat pastry flour
2 tablespoons sugar
2 teaspoons baking powder
½ teaspoon baking soda
 Scant ½ teaspoon salt
½ cup (1 stick/115 g) unsalted butter,
 chilled and cut into small pieces
¾ cup (180 ml) buttermilk
1 egg, separated
½ cup (85 g) chopped fresh or
 frozen strawberries

Preheat the oven to 375°F (175°C). Line a baking sheet with parchment paper. In a medium bowl, mix together the flours, sugar, baking powder, baking soda, and salt until thoroughly combined. Using two knives or your fingertips, add the cold butter into the dry ingredients until it resembles coarse breadcrumbs. Pour the buttermilk into a small mixing bowl. Add the egg yolk and beat well. Slowly pour the wet ingredients into the dry and bring the batter together lovingly using a wooden spoon, or your hands, as I do.

Sprinkle a little flour onto your countertop and place the fully mixed mass of dough on top of the flour. Pat the dough down to about a 1-inch (2.5-cm) thick round. Using a sharp knife, cut the round into 8 triangles. Wipe the knife clean, then cut the scones horizontally, three-fourths of the way open. Sandwich about 1 tablespoon of chopped strawberries between the halves, then press the tops of the scones back onto the bottoms and seal them at the tips. (The sides will still gape open slightly, but that is okay.)

Move the scones to the prepared baking sheet and brush some egg white on the top of each. Bake for 25 minutes or until golden brown. The strawberries will ooze out a bit from the sides of the scones as they bake, but that makes these treats even more lovely. Eat the scones warm with yogurt or more butter if you like!

Good Luck Frittata

In the southern United States, where my husband is from, collards and black-eyed peas are traditional New Year's fare. According to folklore, the little beans represent coins and the greens represent paper money, and eating both assures a profitable year. **MAKES 4 SERVINGS**

³/₄ cup (125 g) dried black-eyed peas
4 tablespoons (60 ml) olive oil
1 medium onion, chopped
3 cloves garlic, minced
1 small bunch collards (about 1 pound), leaves stripped from ribs and chopped
¼ cup (70 g) spicy or sweet pickled peppers
½ cup (90 g) long-grain white rice
²/₃ cup (165 ml) water
4 large eggs
1½ teaspoons salt
¼ teaspoon black pepper
 Sour cream, hot sauce, and chopped cilantro, for toppings

Soak the black-eyed peas overnight in enough water to cover. Drain the peas and transfer to a saucepan. Add water to cover, bring to a boil, then simmer the beans until soft, 20 to 30 minutes. When done, drain and set aside.

In a heavy-bottomed saucepan, heat 2 tablespoons of the olive oil over medium heat and then add the onion and garlic. Cook until the onion has softened, stirring occasionally, about 5 minutes. Add the chopped collards and pickled peppers and continue cooking until the greens have wilted. Add the rice and cook, stirring, for another minute. Stir in the water, cover, and cook over low heat until the rice is tender and the water is absorbed, about 15 minutes.

In a separate bowl, beat the eggs thoroughly. Fold in the drained black-eyed peas, the rice and vegetable mixture, and the salt and pepper.

In a 10-inch (25-cm) cast-iron skillet, heat the remaining 2 tablespoons of olive oil over moderate heat, tilting the skillet to distribute it evenly. Transfer the egg mixture to the skillet, smooth the top with a spatula, and cook, without disturbing, until the underside of the frittata is golden and set, but the top is still wet, about 10 minutes.

While the frittata is cooking, preheat the broiler. Broil the frittata about 3 inches (8 cm) from the heat source until the inside is set and the top is golden, about 10 minutes.

Cut the frittata into wedges to serve, and invite guests to top their serving with sour cream, hot sauce, and cilantro.

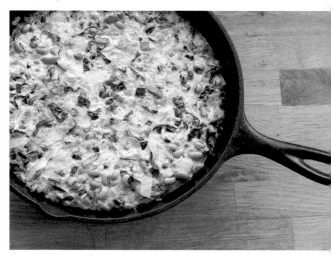

WINTER HOME

There is one thing that always gives me a comforting feeling, especially in the winter when days are dark and time moves slowly. It is to gather loved ones in my home—as my parents did before me. Over the years, I've been known to throw elaborate parties, but this winter my plan is simple. I will make a big pot of something that stews all day and set out the plates and forks in stacks and piles so everyone can help themselves. I will bake a cake and light candles because cake and candles always make a gathering feel special. I will fill my home with the glow of togetherness—loud talking, kids running, and food cooking—and its lingering vibrations will sustain me.

Warming Up Tea

January is a long, cold month in Maine. Here is a simple tea that warms the body and increases circulation. This can be made with or without warmed milk or nut milk. I sweeten it with a generous dose of honey. You can adjust the cardamom and cloves based on how spicy you like your tea. I like a lot of spice! **MAKES 1 CUP**

5–10 whole cardamom pods
5–10 cloves
½ teaspoon powdered ginger or chopped fresh ginger
1 teaspoon nettle
½ teaspoon dandelion
Tea sack (available at grocery stores)
1–2 cinnamon sticks
Honey, for sweetening
Milk or nut milk, warmed (optional)
Freshly grated or powdered nutmeg, for sprinkling

Combine the cardamom, cloves, ginger, nettle, and dandelion in a tea sack and drop the sack into your mug. Add the cinnamon stick. Fill the mug with boiling water. Stir in honey to taste. Add milk if desired. Let steep for at least 5 minutes before removing the tea sack. Sprinkle with nutmeg and enjoy.

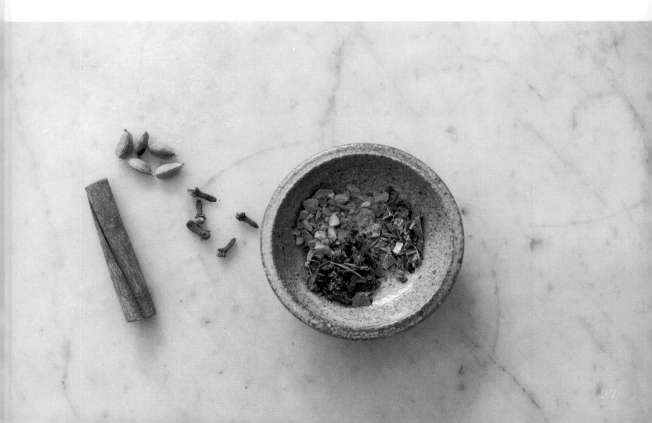

Spoon Oil

In the new year, after weeks of holiday cooking and repeated washings, I like to give my wooden spoons, cutting boards, and bowls a little nurturing with spoon oil, a salve/conditioner that improves their appearance and keeps them stain- and odor-resistant. I always split my batch into two jars, so I have one to send to a friend (this time to MAV). **MAKES 1 PINT (½ LITER)**

2 ounces (57 g) beeswax or beeswax pastilles

Box grater and kitchen scale (if your beeswax is in brick form)

1 cup (240 ml) walnut oil (or less expensive mineral oil)

A few drops of essential oil, such as lemon or rosemary (optional)

Approximately pint-size (½ liter) jar, for heating (plus an extra jar if sharing)

Fine-grit sandpaper

If your beeswax is in brick form, grate on the large holes of box grater until you have 2 ounces (57 g) on your kitchen scale. Pour the walnut oil into the jar for heating. Fill a saucepan halfway with water and place the jar inside, making sure that the water does not rise higher than the top of the jar. Heat the water just until simmering. After the oil has warmed, add your grated beeswax (or pastilles) to the jar. Stir gently with a chopstick or the handle of a wooden spoon until the beeswax melts and emulsifies with the oil into a clear yellow liquid, free of any bits of beeswax. If you wish, add a few drops of essential oil. Using an oven mitt, remove the jar from the water and

allow the contents to cool and solidify. If you'd like to share your spoon oil, divide it between two jars while it is still in liquid form.

To use the spoon oil, buff any rough spots on your wooden spoons, cutting boards, or bowls with a fine-grit sandpaper. Using your hands, coat the wood generously with the oil, rubbing it into the grain. Allow the wood time to absorb the oil—I usually lay out my wooden implements on a tea towel overnight, but a few hours will suffice. Rub excess oil away with a clean cloth and buff to shine. Store spoon oil in a cool, dark place.

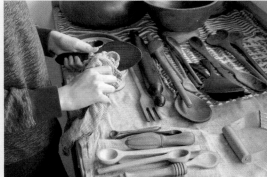

Wool Mending

I keep a basket of mending tucked away under the sofa to work on when I have some idle time. In winter, it is full of woolens—worn heels and elbows, torn thumbs on mittens, bug holes from summer storage. Darning knits the traditional way with a needle and yarn takes some skill, but this needle-felted method, while more visible, is easier to execute. This technique works best for holes that are 1 inch (2.5 cm) or smaller in diameter. Choose roving (unspun, but cleaned and sometimes dyed, wool fiber) in a color that blends in with the item you are mending, or choose a contrasting color as I did for my daughter's socks.

Block of foam or felting pad (a piece of Styrofoam will work just fine),
 slightly larger than the hole you are mending
Wool item to be patched
Wool roving, available in small quantities at craft and yarn shops
Cookie cutter (if you'd like to create a shape)
Felting needle, available at craft and yarn shops

Place your foam block or felting pad under the hole you'd like to patch. The patch will be fuzzy on the underside (like the polka dots on my bunnies on page 60) and flat on the other. If you'd like the fuzzy side to show, work from the underside of the garment. If you'd like the flat side to show, work directly on the garment. If you are using a cookie cutter, place it over the hole. Roll a small amount of roving (start with an amount just slightly larger than the hole you are patching) between your fingers, and place

it over the hole or inside the cookie cutter. With caution (felting needles are extremely sharp!), begin stabbing the roving with the needle. The roving will begin to be incorporated into the wool you are repairing. Add more roving if necessary. Your repair is finished when the roving is incorporated and the hole is fully covered. Edges can be touched up with a few jabs of the needle. To set your patch, cover with a flat-woven cloth and press with an iron on the steam setting.

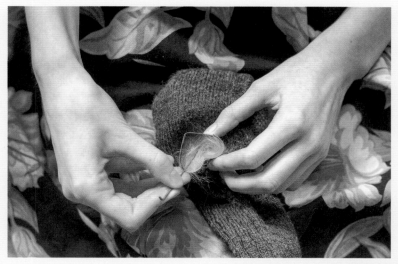

WINTER DAY TRIP

Living in Maine means living with extreme temperatures from season to season. We might experience 9°F in January and 90°F in August. It's part of what I love about living here, but it's also part of the challenge. We have to embrace the winter as best we can or we will find ourselves struggling as the longest season slogs along into March and even April! I make sure to get outside often, and that simple act seems to help me greatly. One way I like to experience the outdoors when it is absolutely freezing, and just too cold to take a long walk, is to take a road trip. I get in my car, alone or with my sweetheart, and drive. I plan to be away for the day, stopping somewhere for a hearty lunch, and hope to see a part of Maine I have not seen before (easy to accomplish in such a massive state).

During this January day trip, the outside temperature was 15°F, and I was reminded yet again just how different this state is when there are no tourists about. Shops are shuttered, motels post "closed for the season" signs, docks and boardwalks are empty, boats are put away in plastic and pulled back onto lawns. Harbors that are packed with vessels of all shapes and sizes from May through September are completely vacant, and icy waters look so much less inviting than they do during the promising days of June and July. Today was a frigid but beautiful day, though I did find my mind wandering to summer. It is coming, I thought. It is coming soon!

MOUNTAIN ESCAPE

Mount Hood is Portland, Oregon's majestic backyard. Only an hour from the city, it is one of our family's favorite escapes in all seasons. This weekend we had hoped for snow while staying at the charming cabin we like to rent, but were greeted with unseasonably warm weather instead. There were no complaints, really, as we explored the creek and fairyland that surround the property, thick with moss and ferns and dotted with tiny mushrooms. We eventually headed to higher elevations for a hike in the snow, stopping to build a snowman and picnic on cookies and tangerines. Our last morning I threatened to hide in a cabinet rather than go home. The only comfort in leaving was knowing I'd be back in the spring.

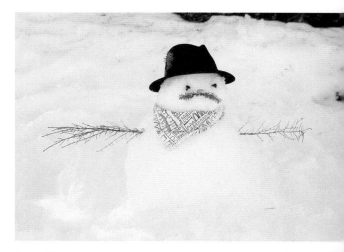

FEBRUARY

HELLO MAV,

Happy February, the longest shortest month. I am glad the days of cajoling my kids into signing valentines to all their classmates are over. Miles in particular used to really struggle with it. One year, the assignment was to write a compliment to everyone in his class—a sweet idea, but a seemingly insurmountable chore for him. When he came home that day, every single valentine to him read, "Miles, you are really good at math."

Are you staying warm? I think February is the month when our climates are most at odds. I have already packed my wool coat away! Still, our weather has been mercurial, transitioning from brilliant sun to pounding rain before I can pull my hood up. Rainbows are our reward for the unpredictability. I trimmed a branch from the tulip magnolia tree out front, which is full of fuzzy buds earlier than I ever remember. I placed it in a vase in a sunny spot in the dining room, and within just days, giant showy pink blooms burst through the pods.

XO,

SCB

DEAR SCB!

I officially don't like this winter and feel very jealous of your tulip magnolia (and you know how I hate to feel jealous). It's sad that I feel so bummed out because I usually love winter. I have always thrived on the cold temperatures, the snow, and the hibernation. This year, however, it just feels too brutal. The temperatures are unbearable, and I now have a small ski hill piled up outside my dining room window. There is so much snow! When I think about the fact that spring is another month or more away, I want to sob.

I started prenatal swimming in a 90-degree pool and am hoping that if I close my eyes, I will be able to imagine that I am in Palm Springs. I promise you, though, that I will continue to get out for some winter walks. I just have to! You know it's not my style to stay indoors all the time. I will pull on my snow pants and force myself. I know that the air, although toxic at first, will be refreshing. More reports and, of course, photographs to come.

HUGS,

MAV

Meyer Lemon Pasta

Here in Maine, we can only find Meyer lemons for a few months in the winter, and I like to take full advantage. I buy them by the bagful and use them in place of regular lemons wherever I can. The taste is truly unique—a bit bitter and more savory than a regular lemon.

 This recipe is my version of the famous Italian *cacio e pepe,* a simple cheese-and-pepper pasta dish enhanced here with Meyer lemons. Perfectly delicious! These instructions are for a single hearty serving of pasta. Multiply everything listed below as needed if you want to serve more people.

MAKES 1 SERVING

3	Meyer lemons
	Salt and freshly ground black pepper
¼	cup (½ stick; 55 g) unsalted butter
⅓	pound (150 g) fresh spinach pasta (dried and/or unflavored pasta works fine, too)
⅓	cup (30 g) grated Pecorino-Romano cheese, or more to taste
1	tablespoon grated Parmigiano-Reggiano cheese, or more to taste

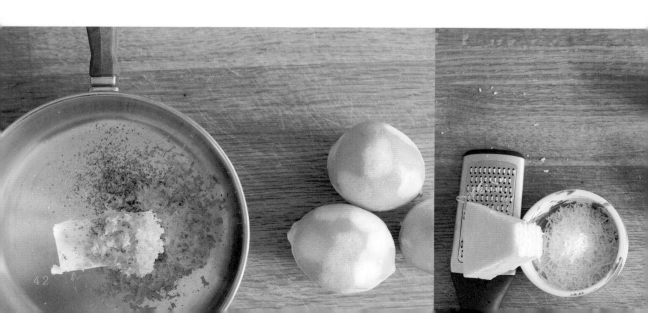

Zest the lemons and set aside the zest in a small bowl. Cut and squeeze 2 of the lemons and set aside the juice in another small bowl. Cut the remaining lemon in half and set aside for garnish. Fill a pot with water for your pasta and set it on the stovetop to boil.

In a small saucepan, combine the lemon zest, at least ½ teaspoon freshly ground pepper, and the butter, and warm gently, stirring, over low heat; take care not to let it crackle. Keep on very low heat while pasta water is coming to a boil.

When pasta water boils, add a generous pinch of salt. Add pasta and cook according to package directions for true al dente. Carefully dip a mug or ladle into the pasta pot to grab and reserve about ¼ cup (75 ml) of the cooking water. Strain the pasta and turn off the heat under the butter mixture.

Return the pasta to the pot, add the reserved cooking water and the butter mixture, and stir gently. Sprinkle at least ⅓ cup (30 g) Pecorino and 1 tablespoon Parmigiano into the pot. (I like at least double the amount of Pecorino to Parmigiano, but adjust the proportions to your own taste.) Add the reserved Meyer lemon juice and stir gently to combine.

Plate your pasta and add more fresh black pepper, salt, and Pecorino to taste. Serve with half of a Meyer lemon on the side to squeeze on just before you dig in!

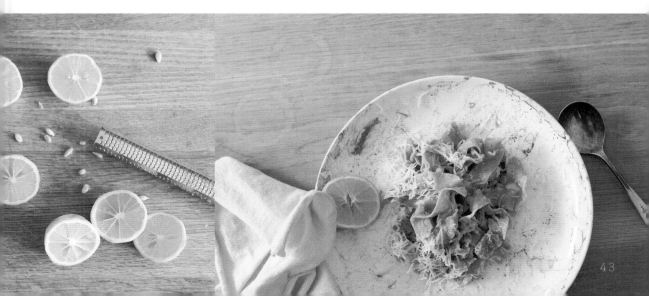

Wintertime Bright Yellow:
A Natural-Dye Project

This is a great, simple project for a cold winter day! I enlisted my trusty sidekick Chloe May Brown, a talented artist and natural dye enthusiast, to help me. Together we dyed cotton jersey yellow using the natural dye Osage orange sawdust, which comes from the Osage orange tree.

Cotton cloth to dye (we cut up
 thrift-store T-shirts)

Aluminum acetate

Osage orange sawdust

Kitchen or postage scale

Medium glass bowl

Small and large metal bowls

Large metal pot

Stovetop or hot plate

Long-handled metal spoon

Strainer

Face mask from hardware store
 (optional)

Liquid thermometer (optional)

NOTE: I purchased our natural dye supplies from Long Ridge Farm (longridgefarm.com). Once you've dyed with these kitchen tools, you can't use them for food preparation, so I suggest acquiring them from a thrift store, yard sale, or other inexpensive source and labeling them carefully.

Prepare the cloth: Wash and dry the cloth and cut it if necessary. We cut our T-shirts into six 22 x 18-inch (55 x 45-cm) rectangles, not counting the rolled edges. Weigh your fabric: Our bundle weighed 9 ounces (255 g).

Calculate 5% of the weight of the cloth to determine how much aluminum acetate you will need. Aluminum acetate is a mordant (a substance used to set or enhance fabric dyes). For our 9 ounces (255 g) of fiber, we used ½ ounce (14 g) aluminum acetate. (To calculate this quantity, we used a simple percentage equation: 9 x .05. You will replace the 9 with whatever your fabric weighs to find your ounce measurement.) Put on the face mask, if desired, or just be sure not to breathe deeply at this point.

Put the aluminum acetate in a medium glass bowl and gently pour in enough hot water to dissolve it fully.

Transfer the alum solution to the metal pot, then add the fabric and enough water to fully cover the fabric. Over low to medium heat on a stovetop or hot plate, heat the water until it reaches about 100°F (38°C) and keep it at a consistent temperature for about an hour, stirring the fabric with a long-handled metal spoon every 10 minutes to ensure that the alum is distributed evenly. Take care not to let the water get too hot; you do not want it to boil or even simmer.

When the hour is up, pour the water and the fabric into a strainer and let the fabric cool a bit. Once cooled, give the fabric a quick rinse in warm water. If you want to wait until the next day to complete your dye project, you can keep the wet fabric in a zip-tight plastic bag overnight. If you are ready to proceed, leave the fabric in the strainer and prepare your dye bath.

 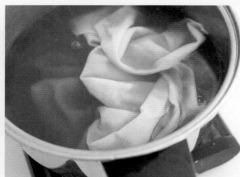

Dye the cloth: Rinse and fill up the metal pot with enough water to cover the fabric, but do not return the fabric to the pot yet. Calculate 15–25% of the weight of the fiber to see how much Osage orange sawdust you will need. For example, to achieve the deep shade of yellow shown here, we calculated that we needed 2.25 ounces (65 g) dye (about 25% of our 9 ounces [255 g] of cloth). Weigh the sawdust in a small metal bowl and then stir it into the pot of water. Over low heat, bring the dye water to a very low simmer, then keep the pot lightly simmering on the burner for about an hour, stirring from time to time.

After about an hour, the color will be extracted from the sawdust and the water will be yellow. To strain the sawdust out of the pot and reserve the dye water, pour the dye water through a strainer over a large metal bowl. Return the dye water to the rinsed metal pot and place the pot back on the stovetop or hot plate. Add the fabric to the metal pot and return to a simmer, adding a bit more water to fully cover your fabric, if needed.

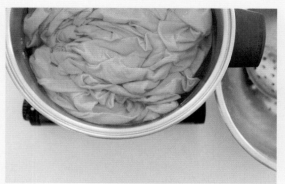

Simmer, stirring from time to time, for a minimum of an hour or however long it takes to reach your desired tone. Remember that the rinsed and dried fabric will be a few shades lighter. We simmered our fabric for an hour to get the shade you see in these photographs. You also can try simmering the fabric for an hour, then turning off the heat and letting the pot sit overnight. An overnight stretch can be a nice way to ensure that your fabric picks up as much dye as the bath has to offer.

Remove the fabric from the dye bath and rinse until the water runs clear. From there you can throw your fabric into the washer and dryer and prepare it for use. Wash the dyed fabric alone the first time around so the yellow color will not transfer to other garments.

Winter's Chicken Soup

Chicken soup holds an important place at our family table. I make it near weekly, usually using the leftover roast chicken from Sunday dinner, along with whatever seasonal ingredients we have on hand. **MAKES 4 SERVINGS**

2	tablespoons olive oil
2	carrots, peeled and sliced into half moons
2	celery stalks, thinly sliced
3	cloves garlic, crushed through a garlic press
6	cups (1.4 L) chicken stock (recipe follows)
½	pound (225 g) dried wide egg noodles
1½	cups (295 g) shredded cooked chicken
1	teaspoon lemon zest
	Salt and pepper
	Handful of fresh flat-leaf parsley
	Lemon wedges

In a large, heavy-bottomed stockpot, heat the olive oil over medium heat. Add the carrots and celery and sauté until the vegetables soften, about 5 minutes. Add the garlic and sauté another minute or until the garlic is golden. Add the chicken stock and bring to a gentle boil. Gently slide in the egg noodles, stirring to separate them, and boil for time called for on package. Stir in the shredded chicken and lemon zest, and continue cooking for a few minutes more until the chicken is heated through. Season with salt and pepper to taste. Ladle into bowls and garnish each serving with fresh parsley and a squeeze of lemon juice.

CHICKEN STOCK

1	chicken carcass from a roast chicken, picked clean of meat
1	leek, washed and trimmed
1	carrot, roughly chopped
1	celery stalk with leaves, roughly chopped
4–5	whole cloves of garlic, unpeeled
5–6	peppercorns
	Sprig of thyme
	Sprig of flat-leaf parsley
2	quarts (2 L) water

Combine all the ingredients in a large pot over high heat and bring to a boil. Reduce the heat and simmer, periodically skimming any foam from the surface, for 2 hours. Pass liquid through a fine-mesh strainer into a large bowl; discard the solids. If not using the stock immediately, cool slightly and place it in an airtight container. Stock will keep for a week in the refrigerator, or longer in the freezer.

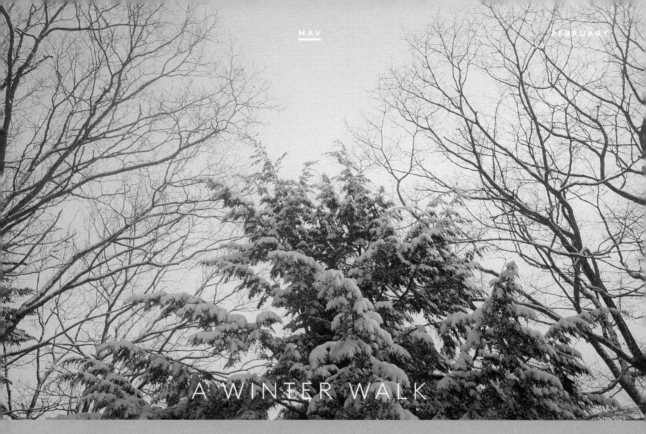

A WINTER WALK

I did not take many walks in January, but in February I forced myself to get out into the fresh air. I layered and pulled on the wool. The snow has been relentless, keeping any promise of spring far out of my mind, but I try to find the beauty in winter. The light is bluer. The air is crisper. The sun is warmer (simply because it's the only warm thing outside, period). I search for signs of growth under all of the ice.

MARCH

DEAR S C B !

It's just the second week of March and yet I have so much to tell you. Of course, you know my mom has been in the hospital since March 5, and things here have been very stressful. Fortunately, however, she is slated to go into rehab in a few days, and from there home, and her spirits are actually fairly high. She is such a fighter. I continue to be amazed by her strength, and she feels the same about mine. We have been inseparable. I have been visiting her every day, sometimes for the full day, and feel beyond scared at the thought of losing her. She is the brightest light in my life! It just can't happen. I will try to keep my thoughts calm and zenlike for her and for the baby. I must!

 We have met some wonderful people along the way in the hospital. The nurses are incredible, and my mom already has her favorites, of course. What a difficult job! I have no idea how they can care so deeply for people who come in and out of their lives so quickly. There are many things that I don't like about the hospital, however, and I can't wait to get my mom out of there.

 Meantime, we still have no signs of spring. Can you please send me more photographs of all of the blooms you have in your life? I would be most grateful if I could live through you. Your March seems to be ever so much more beautiful than mine. I will be in touch as I have more news.

BIG HUGS,

MAV

DEAR MAV,

I have begun walking the five-mile round trip to and from my studio. Ever since I gave myself over to the extra time it takes each day, it has become my refuge. I call it vernal therapy. We are in full fragrant spring now, and I wish I could package up the sweet smells and carpet of blossoms for you. You and your mom have been in my thoughts daily. I am amazed by your strength as you nurture the little life inside of you as well as advocate for and comfort your mom. I know that the two of you are bringing your feisty spirits to even the most clinical of settings, but my wish is that you will both be back in the comforts of home soon.

I am hoping you will all be together for Easter next month—I know how both you and your mom love family gatherings and celebrations. My often-jaded teens have surprised me with their enthusiasm for our own spring traditions this month. On a quick trip to the market last week, they excitedly brought me the candy eggs we use for our coconut nest cookies. Sugar is the gateway to family unity.

BIG HUG
AND LOTS OF LOVE,

SCB

Coconut Chocolate Chip Cookies

I love this recipe for a traditional chocolate chip cookie with a bit of a twist! For cookies that are crispy on the outside and chewy on the inside, open the oven halfway through the baking process and gently push down the tops of the cookies with a wooden spoon, wiping the spoon after pressing on each cookie so the chocolate does not get messy. **MAKES 36 LARGE, OR 60 TINY COOKIES**

2	cups (250 g) whole-wheat flour
½	cup (50 g) almond meal (or finely ground raw almonds)
1	teaspoon baking soda
1	teaspoon salt
½	cup (1 stick/115 g) unsalted butter, at room temperature
¼	cup (75 ml) coconut oil, melted and cooled to room temperature
¾	cup (165 g) packed brown sugar
¾	cup (150 g) sugar
2	large eggs
2	teaspoons vanilla extract
1½	cups (260 g) dark chocolate chips
1	cup (85 g) unsweetened shredded coconut

Preheat the oven to 350°F (175°C). Line a baking sheet with parchment paper.

In a medium bowl, whisk together the flour, almond meal, baking soda, and salt; set aside. In a standing mixer with a paddle attachment, cream together the butter, coconut oil, and sugars. Beat until very light and fluffy, about 5 minutes. Add the eggs, one at a time, beating well and scraping down the bowl after each addition. Add the vanilla and beat the mixture well. Add in the dry ingredients and mix on low speed briefly. When the dough has barely come together, stop the mixer and add the chocolate chips and coconut. Again, mix on low speed until the chocolate chips and coconut are evenly distributed.

For tiny cookies, scoop teaspoon-size dough balls onto your prepared baking sheet and bake for 10 to 12 minutes or until cookies are slightly browned. For medium-size or large, pillowy cookies, scoop tablespoon or rounded tablespoon size dough balls and bake for 12 to 14 minutes. Let cool on the cookie sheet for 5 minutes before transferring the cookies to a wire rack to cool completely.

Coconut Macaroon Nests

My kids ask to make these treats as soon as Easter candy appears at the market. The coconut macaroons are terrific without the candy the rest of the year as well. They only require a handful of ingredients and are gluten-free!

MAKES 12 COOKIES

2	egg whites
1	vanilla bean
2	cups (170 g) unsweetened shredded coconut
²/₃	cup (135 g) sugar
	Pinch salt
1	(10-ounce/283-g) package candy-coated chocolate egg candy

Preheat the oven to 350°F (175°C). Line a baking sheet with parchment paper.

In a mixing bowl, lightly beat the egg whites with a fork just until frothy. Cut open the vanilla bean and, using a paring knife, scrape out the seeds into the egg whites. Add the coconut, sugar, and salt. Stir to combine. (Use your hands, if necessary, to make sure the coconut is evenly coated.)

Make tablespoon-size mounds of dough on the prepared baking sheet. Bake until lightly browned, about 15 minutes. Using a spatula, gently transfer the macaroons to a wire rack. While the macaroons are still warm, gently press 3 candy eggs into the top of each one to create a nest. Allow the nests to fully cool before serving.

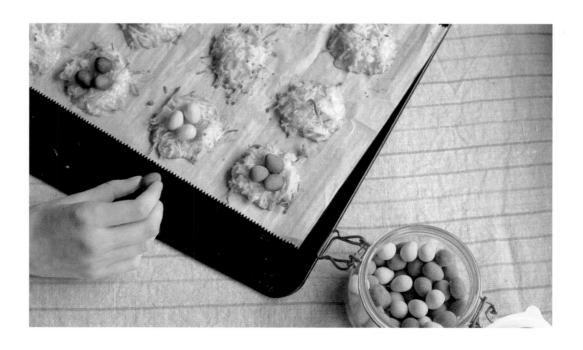

Woolen Stuffed Bunnies

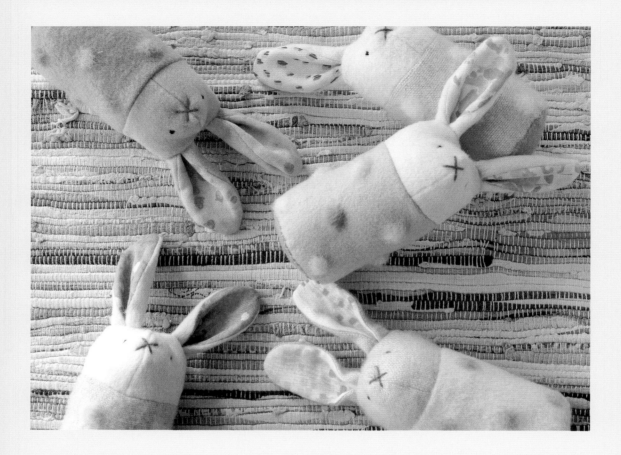

With Easter approaching, I decided to make a batch of bunnies for some of the little ones in my life (and MAV's little-one-to-be!). They differ a great deal from the other soft sculptures I make in that they are meant to be grabbed and mouthed and squished and shaken, not merely put on display. A gentle jingle from bells sewn inside, fuzzy polka dots, and long ears for grasping contribute to a sensory experience for baby. Woolen fabric and stuffing are naturally anti-microbial and water-resistant. I love making and giving these guys!

Paper pattern pieces (see pages
202–203)

Wool fabric for bunny body, head, ears,
and bottom (see Fabric Note)

Cotton print for ear linings
(see Fabric Note)

Wool roving for polka dots in one or
several complementary colors

Wool stuffing

Three 1/2-inch (12-mm) jingle bells
(optional)

Coordinating thread for machine

Black embroidery floss for eyes

Brown perle cotton for nose

Coordinating embroidery floss for
bunny bottom

Sewing machine

Scissors

Washable fabric marker or pencil

Felting pad or piece of Styrofoam

Felting needles

Hand-sewing needles and pins

FABRIC NOTE: I use woolens from the apparel section. Look for soft fabrics, such as pure wool or a wool and cashmere or alpaca blend. Coatings, melton, and wool felt work well. Your fabric should have some heft, but not be stiff or itchy. I always wash my woolens in the washer and put them in the dryer to full the fibers before cutting. The warm water and agitation remove chemical residue and bind the wool fibers together—making the cutting and sewing of the little pieces much easier. For the ear linings, you will need a thinner fabric, such as quilter's cotton, cotton lawn, double gauze, or silk.

SEWING NOTE: I highly recommend basting the pieces together with a contrasting thread before sewing them on the machine—it is quick work and keeps the tiny pieces from shifting without bulky pins. Simply hand-sew a running stitch along the seam you will be machine-stitching without worrying about keeping the stitches straight or even (since they will be pulled away later). When machine-sewing the bitty pieces, work slowly and deliberately.

Copy and cut the paper pattern pieces. Pin pieces to fabric and cut out as follows:

3 head pieces in wool

2 ears in wool

2 ears in cotton accent fabric

1 body in wool

1 bottom in wool

Mark head pieces with washable fabric pencil or pen, using the pattern piece as a guide.

Pin or baste ear lining to wool ear, right sides together. Stitch with 1/4-inch (6-mm) seam allowance. Trim and notch seam. Turn right side out and press flat. Repeat with the other ear pieces. At the bottom of each ear, fold into the center. Press and baste to hold in place.

Pin or baste and sew two of the head pieces (right sides together) from the midpoint of the top (point A) to the bottom (point D) with a 1/4-inch (6-mm) seam allowance.

Open up the two head pieces with right sides facing you and pin or place each ear, with the lining facing down, between the two marks (B and C) on each side, with about 1/8 inch (3 mm) of the raw edge bottom of the ear sticking out from the head piece (see photo 2 on page 63). Place your third head piece on top, right sides facing, matching up points A and D. Baste or pin in place and stitch from point A to D on each side with a 1/4-inch (6-mm) seam allowance (see photo 1 on page 62). Turn bunny head right side out and trim away any exposed basting threads.

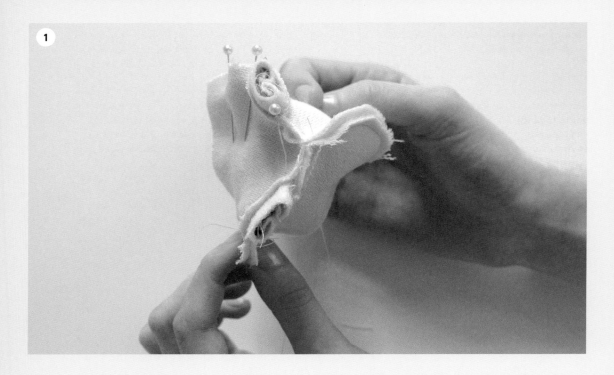

Use a fabric marker to mark the polka dots on the wrong side of the body piece, using the pattern piece as a guide. Take a small scrap of wool fabric and practice the following process before you get started on your pattern piece. Place fabric over the felting pad and take a very small amount of wool roving, rubbing it a bit between your fingers to form a loose ball. Place on the polka dot mark and begin incorporating it into the wool fabric by stabbing with a felting needle (a felting needle tool that holds several needles makes quick work of this). Check on the underside to make sure that the fuzzy polka dot is appearing, and add more roving if necessary. Repeat process for the other polka dots, alternating colors if you wish.

Fold the body over and stitch up the side with a ¼-inch (6-mm) seam allowance. Take the resulting tube and place the bunny head inside, ears side down. Match up raw edges with the seam of the body placed at the midpoint of the back of bunny's head (right sides are together). Baste or pin in place. Stitch together with a ¼-inch (6-mm) seam allowance.

Turn bunny right side out and trim threads. Stuff firmly with wool, taking care to fill in the corners and seams of the head (a chopstick is helpful here). When the bunny is about three-fourths full, wrap three jingle bells in the stuffing and place them inside the center of the bunny cavity. Continue stuffing until full and firm.

With a strong thread, pass a running stitch about ½ inch (12 mm) from bottom of bunny and cinch to draw closed. Secure with a knot and trim thread (see photo 3 on page 63).

Take your wool bottom piece and pin it to the bottom of the bunny. Use a blanket stitch to hand-sew it in place.

Thread an embroidery needle with the brown perle cotton and knot the end. Draw your needle down through one of the pocket corners in the ear to hide the knot and up about one inch from the top seam of the bunny's head and ¼ inch (6 mm) from the center seam. Form an X by crossing the floss over to the other side of the seam about ½ inch (12 mm) down, then up again and across (see photo 4 below). Navigate the needle up through the opposite ear from where you started, hiding the thread in the pocket corner again, and tie a knot to secure.

Mark two dots for the eyes. They are much lower than you would expect, just below the top of the nose and about an inch from the center seam on each side. Thread a double length of black embroidery floss, but do not knot it. Pull your needle up and through the marked spot, leaving a small tail of thread. Make a small X, then another and another to form an asterisk (see photo 5 below). Pull the needle and thread out and trim threads. Repeat on the other side.

Gently wash away any fabric markings with water and your bunny is ready! Bunny may be surface cleaned or washed by hand with wool wash if necessary.

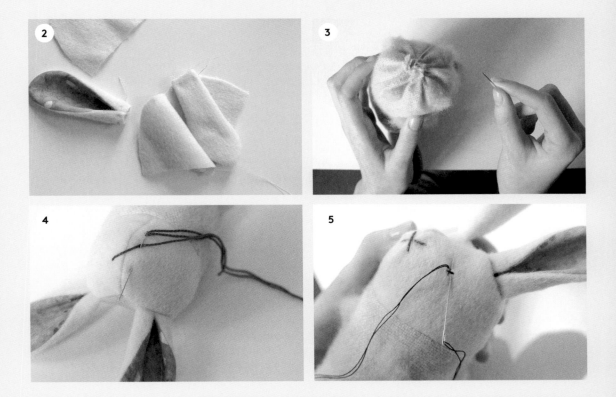

Geometric-Stencil Eggs

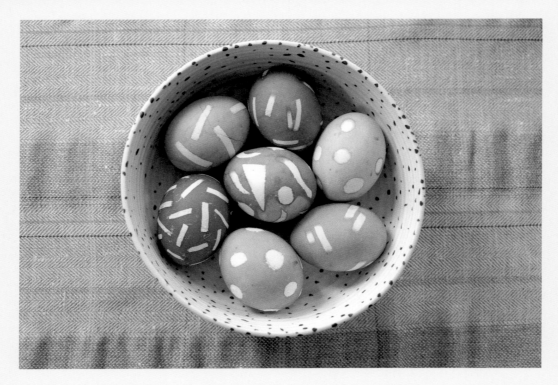

My family and I have been coloring eggs with natural dyes every spring for years. The surprisingly vibrant blue we get from cabbage is our favorite color (and worth the farty stink that comes with boiling it for half an hour). This spring we used sticky-back craft foam to create geometric stencils. Although the little stencils look a little fussy, the thick foam actually makes them easy for even small hands to hold.

For the dye

1 head purple cabbage

2 quarts (2 L) water

¼ cup (60 ml) white vinegar

¼ cup (68 g) salt

Roughly chop the cabbage and place it in a large stockpot with the water. Bring to a boil and then reduce the heat to a simmer. Cook, stirring occasionally, for approximately 30 minutes. The water should be a deep blue. Strain out the cabbage leaves and mix in the vinegar and salt while the dye bath is still warm. Allow to cool before dyeing the eggs.

For the stencils

Cooled hard-boiled eggs

Sticky-back craft foam sheet

Fine-point scissors

Cut geometric shapes from the foam. We cut lines, squiggles, triangles, and irregular circles. Anything goes! The wonkier, the better. Peel away the sticky back and gently but firmly press the sticker shapes onto the eggs with your fingernail. Create a regular pattern around each egg or go wild with a wide variety of shapes.

Using a spoon, gently lower your eggs into the cooled cabbage dye bath and allow them to saturate to the desired shade. We took them out at varying intervals, ranging from after 5 minutes to after an overnight in the refrigerator, so we'd have a variety of shades of blue.

After removing the eggs from the dye bath with a spoon, allow them to thoroughly dry on a rack, then gently lift away and discard your stencils.

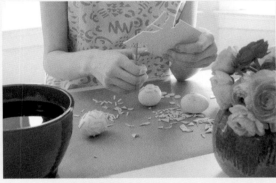
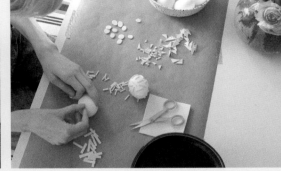

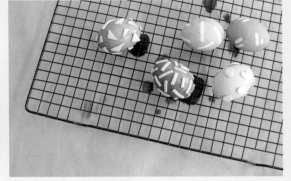

EARLY PREGNANCY LIFE SAVERS

As I moved out of the first trimester of pregnancy—during which I often felt off—I expected to be running marathons. But, much to my surprise, I did not feel truly well again until around week 20. Luckily, I figured out some routines that really helped me cope. I hope these notes will be helpful to other women who are pregnant, thinking about becoming pregnant, or are just thinking about their health in general.

READ

I read three novels during my first trimester, which was more than I had read in a long time. It was good to have a nice stack of books to distract me from feeling anxious or unwell. Like every mom, I felt like I needed to read a book about pregnancy, but I am easily overwhelmed so I limited myself to one: *The Natural Pregnancy Book* by Aviva Jill Romm. It has great advice for every little ache, pain, and emotion.

EAT

Just weeks after finding out I was pregnant, I already knew I was going to have to cut back on heavy, rich, and other hard-to-digest foods. These foods were just making my life more difficult, and I needed to keep things simple! I encourage you to find what works for you and stick to it at least for the first three months. It may be hard to give things up, or add things in, but it is entirely worth it. These are some of the snacks that kept me going: veggies and hummus; cheese and crackers; raw almonds; yogurt and banana; apple and peanut butter.

DRINK

Giving up red wine was hard for me. I still wanted to have a special beverage when I went out with friends. Here are two of my favorite combinations, both delicious and very good for digestion!

Grapefruit and Tonic
Poured into a tall glass with lots of ice. Freshly squeezed grapefruit juice is a must!

Club Soda and Bitters
Poured into a short glass with a bit of ice, and garnished with an orange slice.

TAKE CARE

It is important that you find a way to take care of yourself during the early months of pregnancy. I tried out different remedies and found that what worked one day didn't necessarily work the next, so I got used to switching them up.

For nausea I used vitamins B_6 and K (50 mg of each per day), fresh ginger (chopped and steeped in hot water), slippery elm (lozenges), and saltines (plain or with a bit of butter). For exhaustion I increased protein, increased iron (by eating more iron-rich foods), and used passionflower (10 drops of a tincture a few times a day). For insomnia I increased gentle exercising like walks, took magnesium (250 mg before bedtime), melatonin (3–4.5 mg per night), skullcap (10 drops of a tincture before bedtime), oats (10 drops of a tincture before bedtime), and lavender (2 or 3 drops of the essential oil in my bath before bedtime).

Of course, I did not use all of these remedies at the same time. I rotated based on what was working.

TAKE TIME

During my first trimester I focused on work, sleep, and wellness. I cut out all commitments that weren't truly important or time-sensitive. This streamlining helped me feel less scattered and more focused on supporting the early changes that were

happening within my body, mind, and spirit. I found it was important to find ways to slow down.

BELIEVE

There is so much uncertainty in the beginning days and weeks of pregnancy. It is hard not to give in to anxiety. I set up a little area on my bedroom mantle, as well as on the wall near my bedside, where I could put little good luck charms, crystals, drawings, and photographs. I used these areas as energy touchstones to turn to in those moments when I felt unsure. I would repeat calm thoughts in my head, in meditation, reminding myself that every day was another day in my journey no matter where that day led. We cannot control much of what happens in our lives, including during the early days of pregnancy.

REWARD

Emotionally and physically there were times when I just felt down during the first 20 weeks of being pregnant. I couldn't put my finger on why and I got tired of thinking about how to help myself. On those days I would either buy, thrift, or make something for the baby. Focusing on what I discovered or what I was making helped me to feel better and, in the process, I gathered a collection of special objects for the baby.

APRIL

DEAR SCB!

Just as April is starting, I have the very best news! My mom was discharged and is now at home with my dad. We are working on new routines and settling her in (she's stubborn about new routines), and it feels incredible to have her back in her own bed. My plan is to see her every day, morning and/or night, and work with her on the little things. I have completely cleared my schedule and am pouring myself into her wellness. As we sit and talk, I try to freeze the moments in my head because I worry that this may be my last year with her. When I have those thoughts, however, I try to vanish them from my mind, but at the same time I think it's good for me to treasure every single moment with her. I have been taking a bath every evening in her honor because she cannot take her long baths anymore (something I remember her doing every night since I was little). The baby seems to like it, and it's a nice quiet time for me to gather my thoughts.

 Meantime, we are finally starting to see some buds blooming. I've never wanted anything more. The yearning for spring that I feel this year comes from deep within my heart, and with each bit of green or pink I see, I feel a burst of love! I am ready for things to settle down. I plan to get back into my own routines this month, including getting ready for this baby! I can't believe she will be here in something like 15 weeks. I have so much to do.

I hope April is good to you!

LOVE LOTS,

MAV

HELLO MAV!

I am glad you are getting back to your routines and finally seeing some signs of spring! Time to start nesting! You have such a talent for creating relaxed, art-filled spaces in your home. I am excited to see what you do in the baby's room. When I was in the final months of my pregnancies, I loved to fold and stack all the little soft onesies and other baby clothes. Those little piles were filled with anticipation.

 The seasons have felt rushed this year in the Northwest. We have already started eating dinners outdoors and have traded our wool socks for sandals. Doing this project with you, where we visually document our lives, creates a heightened awareness of the passing of time. Since the beginning of the year, the trees in my neighborhood have gone from barren to blossoms to the beginnings of fruit, Mia has dyed her hair three different colors, and your belly has grown round. I am both comforted and astonished by these developments.

LOVE,

SCB

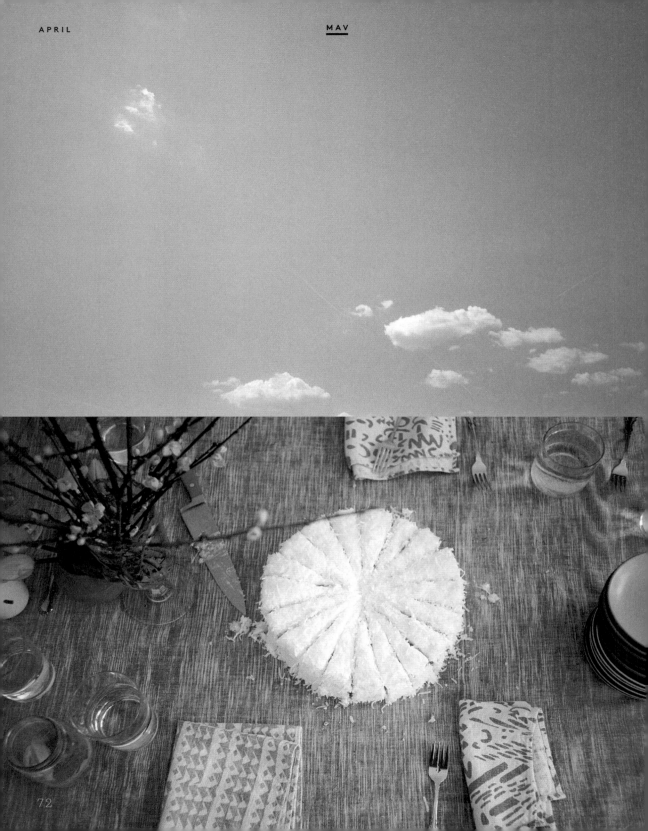

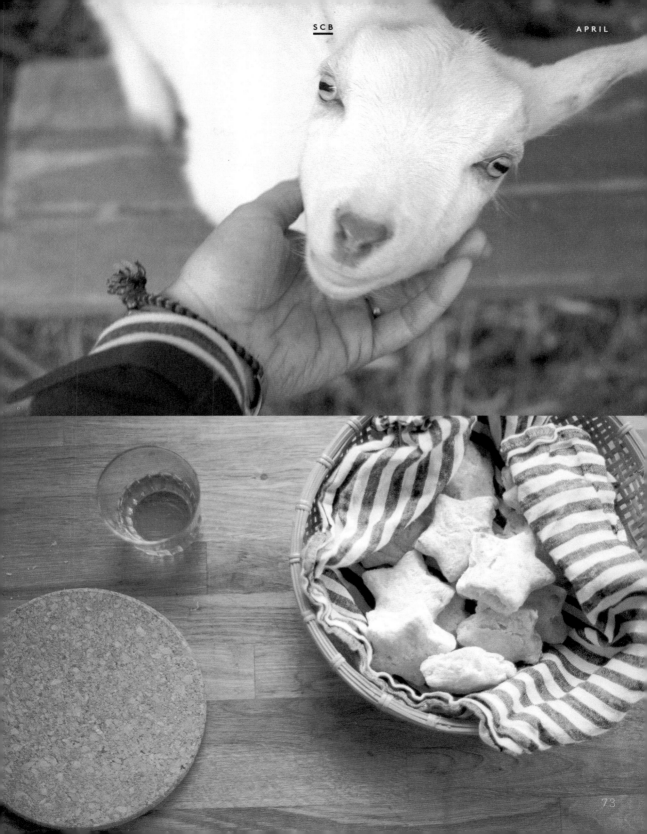

74

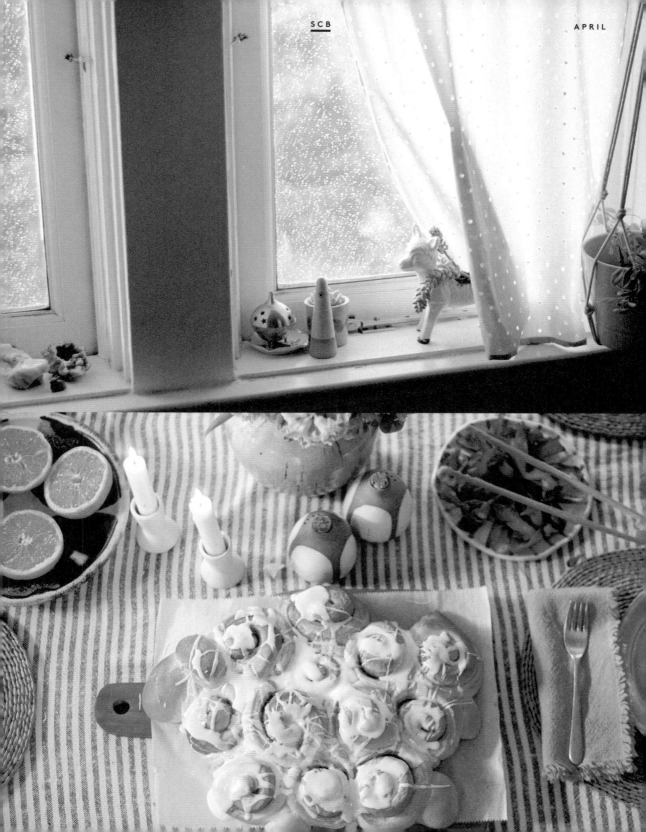

Scratch Baking Co.'s Almond Cake

A couple of miles from where I live, just a few paces from Willard Beach, sits a very special bakery called Scratch Baking Co. I consider it a must for anyone visiting the Portland East area. Over the years, I have had the pleasure of getting to know the owners, Sonja, Bob, and Allison. Sonja, the sweets baker, was kind enough to invite me into the kitchen one April afternoon to share this recipe. Almond cake is a personal favorite of mine. It is just right for a casual gathering, or to snack on while you sit at your kitchen counter.

MAKES ONE 8-INCH (20-CM) CAKE

½ cup plus 1 tablespoon (215 g) sugar
4 ounces (115 g) almond paste (not marzipan)
Zest of 1 lemon
¼–½ teaspoon dried lavender flowers, finely chopped
½ cup (1 stick/115 g) unsalted butter, at room temperature, plus more for greasing
3 large eggs
1 teaspoon vanilla extract
½ cup (65 g) all-purpose flour
½ teaspoon baking powder
½ teaspoon salt
½ cup (about 100 g) fresh or frozen blueberries

Preheat the oven to 350°F (175°C). Grease an 8-inch (20-cm) round cake pan and line it with parchment paper; grease the parchment paper.

In the bowl of a stand mixer with the paddle attachment, combine the sugar, almond paste, lemon zest, and lavender. Mix on low speed until the almond paste is broken up and the mixture looks sandy. Add the butter and mix on medium-high until very light colored and fluffy, scraping the sides of the bowl with a spatula several times along the way. Add the eggs, one at a time, mixing and scraping the bowl after each addition to make sure the ingredients are thoroughly combined. Add the vanilla and mix again. Whisk together the flour, baking powder, and salt in a small bowl, then add the dry ingredients to the wet ingredients. Mix on low speed until it comes together as a smooth batter.

Pour the batter into the prepared cake pan. Sprinkle the top with the blueberries and use your fingertips to gently press them into the batter. Bake for 40 to 45 minutes or until the top of the cake is golden and a cake tester comes out clean. Cool in the pan. Slice into wedges and serve with a sprinkle of powdered sugar if you like. Store in an airtight container for up to a week.

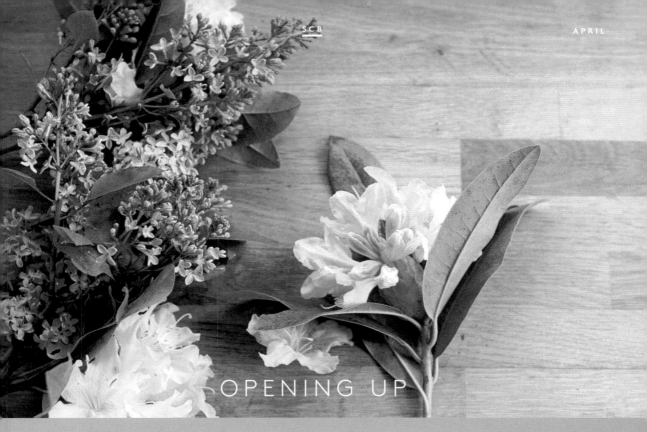

OPENING UP

Springtime is when I want to eliminate the division between outside and inside. Windows and doors are flung open, letting in all the sweet fragrance, cool breeze, and warm light. Every spare vase and jar is filled with blooming branches and the gathered posies that, once this spring fever has worn off, I will recognize again as common weeds. Sheets are hung on the line to soak up the sunshine and houseplants are placed on the front stoop to drink in April showers. I open myself to this new green world.

Natural Spring-Cleaning

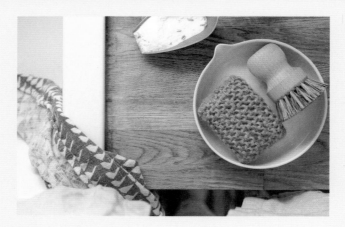

When the persistent gray of our northwest winter gives way to spring sunshine, I start to see my home in a literal new light, and it's time for some deep spring-cleaning. Over the years I have developed my own arsenal of homemade cleaners based on supplies from my kitchen pantry, and they do the job quite well without all the dyes, chemicals, and artificial scents of commercial products.

Hand-Knit Sisal Scrubbies

I use these scrubbies to wash dishes and scrub surfaces in the kitchen; you also could set one aside for exfoliating in the bath.

1 200–300 foot (60–90 meter)
 ball sisal one-ply twine

Size 9 (5.5 mm) knitting needles

Tapestry needle

1 piece of natural cellulose sponge,
 roughly 2 × 3 × ¾ inches (5 x 8 x 2 cm)

Divide the twine into two balls of relatively equal size. With a double-length of twine (one strand from each ball), cast on 12 stitches on the knitting needles. Knit for about 6 inches (15 cm), or approximately 18 rows. Bind off.

Fold the knitted fabric in half to form a shorter rectangle. Thread a length of twine on a tapestry needle. Starting at one of the corners of the rectangle, near the folded edge, stitch the knitting closed with a whipstitch. When you reach the final side, insert the sponge and pull the knitting closed around it. Continue to stitch the opening closed, knotting and hiding the tail of the twine at the end. When necessay, wash on top rack of dishwasher.

Window/All-Purpose Cleaner

I use this cleaner on windows, mirrors, stainless-steel appliances, and even wood surfaces and furniture. (I often follow up with some of my spoon oil—see page 28—to nourish the wood.)

1 cup (240 ml) white vinegar

1 cup (240 ml) distilled water

A few drops of castile soap or liquid dish
 soap

A few drops of essential oil, such as
 rosemary or lavender (optional)

Combine all the ingredients in a spray bottle. Spray on soiled surfaces and wipe clean with newspaper or microfiber cloth.

Scouring Powder

I use this on all our porcelain and enameled surfaces: sinks, tub, and the toilet bowl.

1 cup (195 g) baking soda

1/2 cup (about 140 g) salt

2 tablespoons dried lavender or a few
 dashes of the essential oil of your
 choice (optional)

Combine all the ingredients in a large jar. Sprinkle on soiled surfaces and work in with a wet brush or scouring pad (the Hand-Knit Sisal Scrubbie works great). Or spray the powder with all-purpose cleaner and wipe away.

Fabric Deodorizer

I use this on upholstered furniture, curtains, throw rugs—any fabric that I can't toss in the washer. I have been known to spritz it in my kids' sneakers as well.

1/4 cup (60 ml) vodka

1/4 cup (60 ml) distilled water

A few drops of essential oil, such as
 rosemary or lavender (optional)

Combine all the ingredients in a bottle with a fine-mist spray nozzle. Test for color-fastness on a small, less obvious area of the fabric, then spritz well and allow the deodorizer to evaporate. Do not rinse.

Spring Skies: A Natural-Dye Project

I eat a lot of black beans. Nearly every time I soak my beans overnight before cooking, I keep the water and throw in a bit of fabric, a onesie, or a napkin to dye. This is such a simple and natural way to bring more color into my world!

Dried black beans

Cotton fabric, T-shirt, or onesie

Strainer

Large bowls

Iron tablets (optional; see Note)

Soak the beans overnight in enough water to cover them by 3 to 4 inches (8 to 10 cm). For the two small onesies shown here, I used the soaking water from about 16 ounces (455 g) dried beans.

After the overnight soak, place a strainer inside a large bowl, then pour the beans through the strainer, retaining the soaking water in the bowl. At this point you can keep the black bean water, covered, in the refrigerator for up to 1 week, until you are ready to dye.

When you're ready to dye, bring the water to room temperature and immerse your fabric or garment in the water. Soak for 24 hours.

I like to fold or twist my fabric/garment before I add it to the water so the water doesn't hit the fabric evenly. This makes for a nice mottled look. If you want a more uniform color, don't fold or twist the fabric and be sure to stir the dye bath during the first few hours of soaking.

When fabric/garment is done soaking, rinse and wash it as you would normally. The color will fade quite a bit to create a more beautiful, subtle tone of light lavender/blue or gray.

NOTE: Adding iron to the dye will create a darker color; I bought a cheap bottle of 65-mg tablets at the drugstore. In a separate small bowl, just add a few of these tablets to a few tablespoons of warm water and let the tablets disintegrate. Then add the iron mixture to the black bean water before you add your fabric or garment to the dye bath. Proceed with instructions as given.

Honey Lemonade

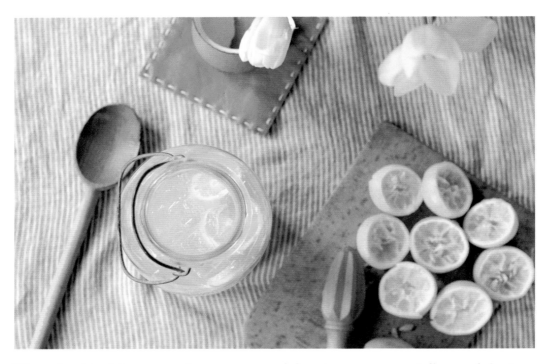

We make this thirst-quencher year-round, but it tastes especially good during the first warm days and outdoor meals of April. **MAKES 6 SERVINGS**

½ cup (120 ml) good-quality local honey
¾–1 cup (180–240 ml) freshly squeezed lemon or lime juice (from about 6 lemons or limes)
3–4 cups (720–960 ml) water

Heat the honey and 1 cup (240 ml) of the water in a saucepan over medium heat for a few minutes, stirring until the honey dissolves. Combine the honey syrup and juice in a pitcher or two-quart jar. If serving immediately, add the remaining 2 cups water and serve over ice. Alternatively, add 3 cups (720 ml) water and chill.

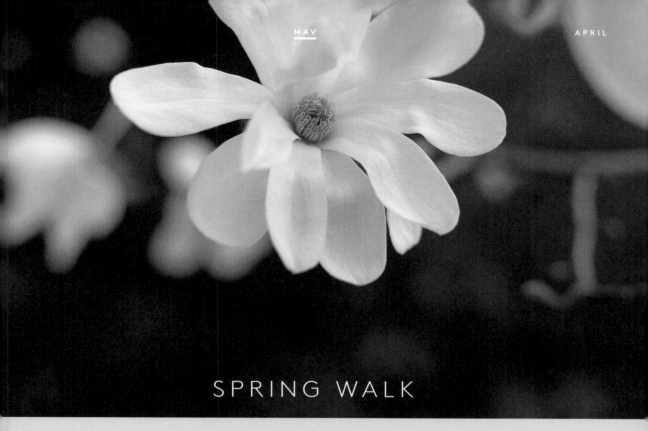

SPRING WALK

My camera is like a trusted friend but one that I don't need to talk to. And that's just what I needed on my walk today.

The coming of the spring buds is almost shocking to me after the long hard winter. There were times when I believed this day would never come and yet here I am, walking among all of the promise and the blooming.

The bits I notice the most this year are the simple green buds. They are not yet leaves or flowers but just the promise of what is to come. They don't create a canopy, the enveloping feeling that the full leaves might have, but instead feel more bare. But there is something special here, something that resonates with me.

Spring, thank you for coming and giving me hope.

MAY

DEAR MAV,

I imagine this is a very special Mother's Day for you as you are on the cusp of being a mom, as well as experiencing a renewed intimacy with your mom. I hope you are having a wonderful day!

 Jack is out of town, but the kids and I packed a picnic and celebrated with our first river day of the year. On our hike down to our secret beach spot, Miles signaled me to hush and pointed to a mama deer and her fawn munching on salmonberries beside the trail. We all stood quietly, two families sharing the forest, before we went our separate ways. After our picnic, we collected wildflowers, sorted river stones into a color wheel, and dipped our toes in the glacial river water (not ready for a swim just yet). There was nothing left to do but stretch out our bare limbs in the warm sun and take a nap. The best feeling.

WISHING YOU WARMTH,

SCB

DEAR SCB!

I am not even sure how to begin this note now that my life has changed so drastically. I really do feel as if someone has taken a chisel and hacked away a part of my heart. We lost my mom on May 17, and as the month comes to a close, I continue to feel worse and worse.

You are right, though, about Mother's Day. It was a very special day for all of us. The photograph I share with you now is from that very day and the last one I took of my mom. As ever, she is beaming, snuggling in with my nephew, Miles— she is always such a beautiful and bright spirit. I wish I could rewind and go back to that day or any moment with my mom. I am heartbroken.

We are planning a remembrance weekend for her in mid-June and, you know me, I am already thinking about the details. How would my mom do the food, the flowers, and the rest of the things that make a gathering special? I wish I could make huge batches of her sugar cookies for everyone, but I know I will not have the time or the strength. Instead, I think I will ask my friends at Tandem Coffee + Bakery to make her favorite apple and blueberry pies. I will keep you posted.

Thank you for all of the love and support you have been giving me of late. I yearn to join you on one of your picnics and just laze around and talk to your kids about anything going on in their world. I remember what it felt like to be just on the cusp of getting out of school, the summer's adventures ahead. What a tremendous feeling.

Let's be in touch soon!

LOVE,

MAV

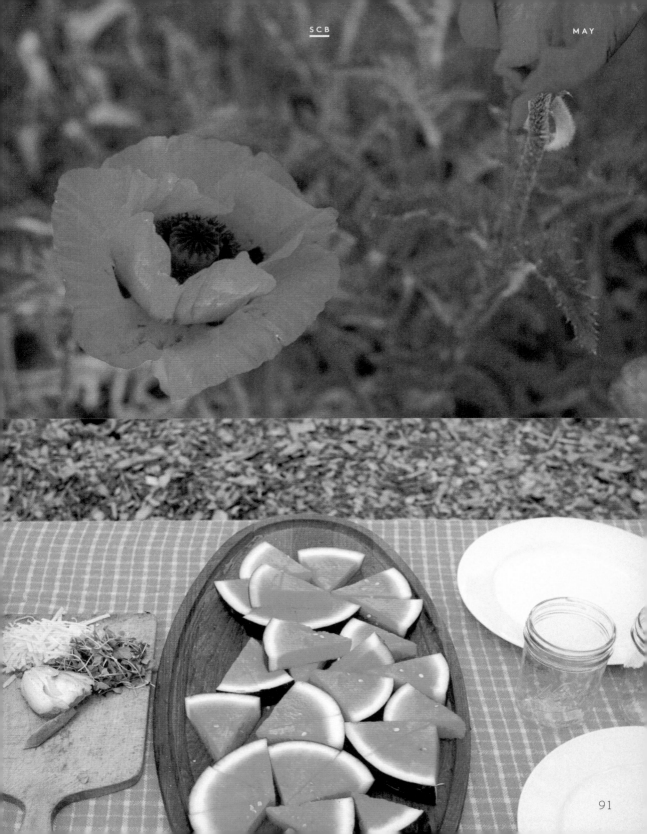

My Mom's Old-Fashioned Sugar Cookies

We include this special recipe to honor my mom. She was a wonderful cook and a generous soul who welcomed all into her kitchen. She never liked it when a guest, or family member, didn't eat and was known to force food on people. She always baked these cookies around Christmastime and sometimes for other special occasions. I will never forget how my mom preferred them: "I like them thin and crispy," she always said. It has taken me awhile to recreate her rolling technique, but I think I've finally gotten it. **MAKES ABOUT 60 COOKIES**

4 cups (510 g) all-purpose flour, plus extra for rolling and cutting
1 teaspoon baking powder
½ teaspoon baking soda
½ teaspoon salt
1 teaspoon ground nutmeg
1 cup (2 sticks/225 g) unsalted butter, at room temperature, plus more for greasing
1½ cups (300 g) sugar
1 large egg
½ cup (120 ml) sour cream
1 teaspoon vanilla extract
Cinnamon-sugar mix (⅓ ground cinnamon and ⅔ sugar), for topping (optional)

In a large mixing bowl, combine the flour, baking powder, baking soda, salt, and nutmeg and set aside. In another large mixing bowl, with an electric mixer or wooden spoon, beat the butter and sugar until light and fluffy. Add the egg and continue to beat. Add the sour cream and vanilla and mix until smooth. Gradually add the dry ingredients to the wet ingredients, mixing well to combine. Get your hands in there toward the end to bring the dough together. Divide the dough into three balls and wrap each one in plastic wrap; refrigerate for at least several hours or overnight.

When you're ready to bake, preheat the oven to 375°F (190°C) and lightly grease one or two cookie sheets.

On a well-floured surface and working with 1 ball of dough at a time, roll out the dough to about ¼ inch (6 mm) thickness (the thinner the better). Leave all of the dough that you're not working with in the fridge; it's easier to roll and cut when it's cold. Using a floured cookie cutter, cut out the cookies. Using a spatula, gently lift and place the cookies on the prepared cookie sheets. The cookies do not spread so they can be placed rather close together. Sprinkle the tops with the cinnamon-sugar mix, if desired, and bake for 8 to 10 minutes, until the edges start to show a golden brown. Repeat with the remaining dough. If you want to reroll the scraps you can put them back in the refrigerator to chill a bit before adding them back into one of your dough balls. Store the cookies in an airtight container for up to a week.

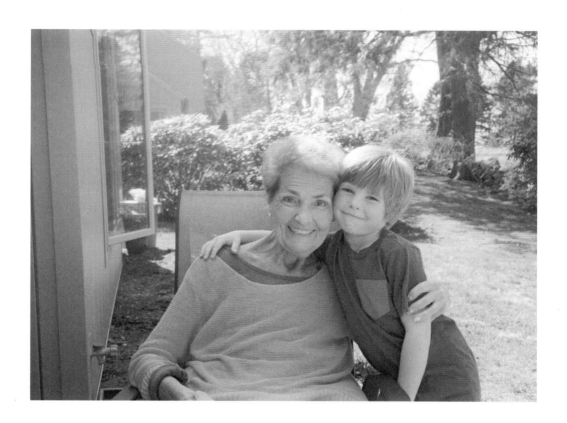

Mom,

I love you always and forever.

Thank you for sharing so many gifts with me,

including this sweet one!

XO,

Your Angel Girl

JUNE

DEAR MAV,

You have been on my mind so much. I came across a quote from Julian Barnes about mourning: "It hurts just as much as it is worth." I know your mother's worth was immeasurable to you, and I imagine your grief feels the same. I hope you are beginning to find comfort in everyday beauty again, the change of light and of the season. Summer is almost here.

I remember your mother as an articulate and elegant woman who exuded warmth and love. Her pride in your accomplishments was obvious. In all our endeavors, she was always our first and most devoted customer. She will forever be *3191 Miles Apart*'s biggest fan, and I see what we are doing this year, documenting our lives—our love of gatherings, of food and family and home—as a fitting tribute to her.

HUGS,

SCB

DEAR SCB!

I am writing to you from our little cottage. I can't believe this is our eighth summer renting the same place. It was the first rainy solstice we have had in years and I quite enjoyed it. I used the day to nap, read, and cry whenever I wanted. Everyone needs a day like this every once in a while! No sense of the time. No real obligation to anyone.

We are getting excited for your July 2 visit. We have so much to catch up on. I ended up giving a short remembrance for my mom at her memorial on June 14. I feel like I could write a whole book about my mom. Maybe I will! Thought you would enjoy this excerpt from what I said:

My mom did not give up on ideas or on people. She was not cynical nor was she negative. Indeed she was critical but she gave her criticisms with love as their intention. It was not that she didn't believe in you, it was that she believed, often, that you could do better.

That relentless drive and dedication, which she spent her life inspiring in others, is what I got to witness in her during this last year and more intensely in her last ten weeks, during which she and I were inseparable.

During these weeks my mom became very sick very quickly and yet she worked with the same intensity to become well again. Even when she believed it might not be possible for her to feel better, in moments she and I shared privately, she was still in disbelief that she could not find a way. For her, and for me, there was never going to be any acceptance of failure, of being beaten, of not believing in even a small possibility of healing.

And so I did get to tell my mom, throughout this very fierce and fast-paced journey, that I was proud of her. I got to tell her that no matter what the outcome was for her body, her spirit, character, humor, resolve, warmth, and love would always and forever be alive within us and that we would all be so very proud of her endlessly.

SEE YOU VERY SOON!

XO, MAV

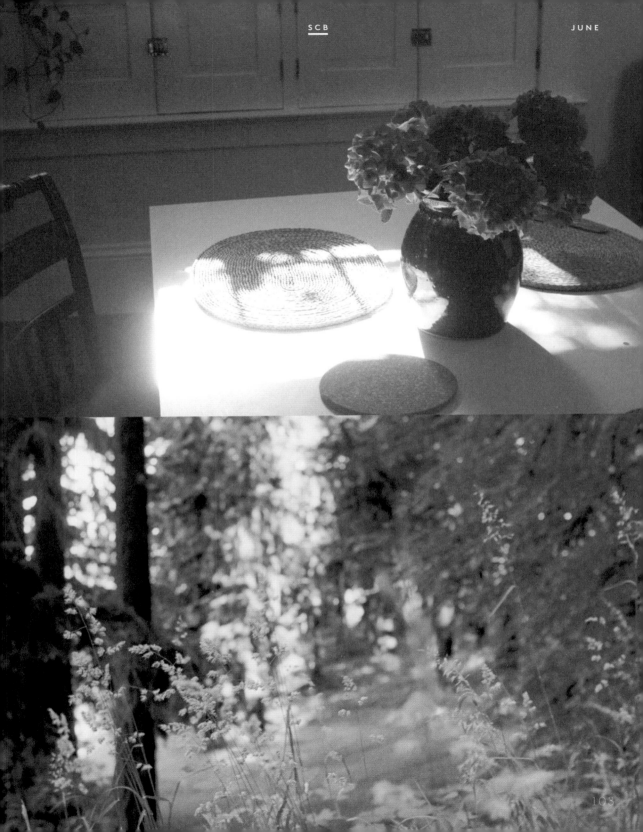

Summer Strawberry Pie

When I was little my parents would invite their friends to visit a lot during the summer, and my mom would often make this pie. What I remember most about those visits is the talking. My mom and dad would sit with their guests for hours, laughing and catching up. My mom was quite pleased when I told her I would include this recipe in our book.

You can make this pie with any prebaked pastry shell or piecrust. I like it with a graham cracker crust so I have included that recipe. Fresh Maine strawberries, cream, and graham crackers are such a perfect combination! My mom always bought her pie shells at the grocery store, though, and I encourage you to do that if you want. It doesn't mean that you didn't put love into your pie. **MAKES ONE 9-INCH (23 CM) PIE**

FOR THE GRAHAM CRACKER CRUST

8 ounces (225 g) graham crackers
 (use any kind of graham cracker you
 like; my favorites are Mi-Del Honey
 Grahams)

¼ teaspoon salt

2 tablespoons maple syrup

1 tablespoon brown sugar

1 tablespoon vanilla extract

5 tablespoons (70 g) unsalted butter,
 melted

Preheat the oven to 350°F (175°C). In a food processor, pulse the graham crackers with the salt until well ground. Add the maple syrup, brown sugar, and vanilla, and pulse a few more times until combined and the finished mixture looks like coarse sand. Transfer to a bowl. Add the melted butter and, using a spoon or your hands, bring the crumbly dough together.

Press the dough evenly into the bottom and up the sides of a 9-inch (23 cm) ungreased pie dish. It is very important that you pack the dough into the dish well, so take your time with this step. You can use the bottom of a flat glass to help if you need more leverage when pressing. When ready, bake for 12 to 15 minutes, until the crust is dry to the touch. Let cool completely before filling with your strawberries and whipped cream.

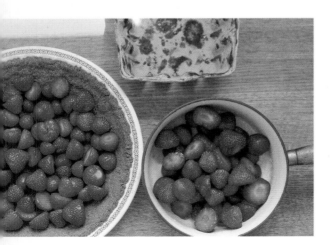

FOR THE PIE FILLING

1 quart (580 g) whole strawberries, hulled
1 cup (200 g) sugar
3 tablespoons cornstarch
1 cup (240 ml) heavy cream
1–2 teaspoons vanilla extract

Arrange half the strawberries in a single layer in the prebaked piecrust. Put the remaining strawberries in a small saucepan and use your fingers to very slightly mash them into large chunks, then bring the strawberries and their juices to a gentle boil. Stir in the sugar and cornstarch until well combined and simmer very gently for about 5 minutes, stirring from time to time, until a thick, dark sauce, still with bits of strawberry, forms. Pour the sauce over the whole strawberries arranged in the cooled piecrust and use a spatula to press and spread it out evenly. Refrigerate the pie for a few hours until it no longer feels warm. Whip the heavy cream and vanilla together using a stand mixer. Spread the whipped cream over the pie and refrigerate for at least 3 to 4 hours. The colder this pie is the better, although if you make it the night before, you risk having a soggy crust. Make it the morning of the day you want to serve, if you're able. Slice carefully with a sharp knife and enjoy!

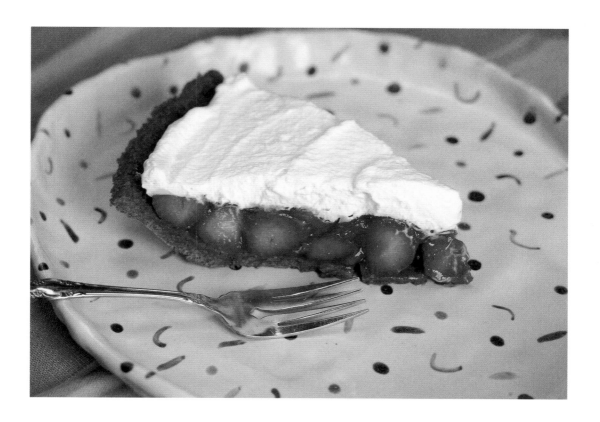

Raspberry Ripple Yogurt Pops

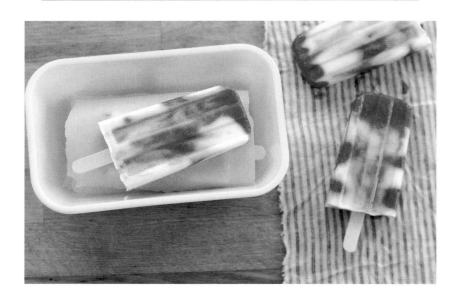

Summer is Popsicle season at our house; sometimes we make a new batch every day. This recipe takes full advantage of the berry bounty of early summer in the Northwest (we picked more than 50 pounds of raspberries, blueberries, and strawberries this year). I use a Norpro ice pop mold that makes ten 3-ounce pops, but you could use this recipe for any Popsicle mold, reserving any leftover mixture for another batch. You might also want to try ice pops made with the Honey Lemonade on page 82, tossing in a few fresh berries. **MAKES APPROXIMATELY 10 POPS**

3 cups (375 g) raspberries
1 tablespoon lemon juice
5 tablespoons (65 g) sugar
1½ cups (360 ml) plain whole-milk yogurt
1 vanilla bean
 popsicle sticks

In a blender or food processor, blend the raspberries, lemon juice, and 2 tablespoons (25 g) of the sugar until liquefied. Pass the raspberry puree through a fine-mesh sieve to remove seeds; set aside. Put the yogurt and the remaining 3 tablespoons (40 g) sugar in a bowl. Split the vanilla bean with the tip of a knife and scrape the seeds into the bowl. Stir until well combined.

Dividing evenly, layer the raspberry puree and vanilla yogurt in the pop molds until they are nearly filled (leave ¼ to ½ inch [6 to 12 mm] for expansion as the pops freeze). To create the swirls, gently poke each pop with the end of a chopstick before placing the lid on the mold and adding the Popsicle sticks. Freeze until firm (at least 4 hours). To remove the pops, run warm water over the outside of the molds and slide them out. Store in the freezer in an airtight container between layers of parchment or wax paper.

SOLSTICE IN MAINE

As an adult, I never used to like the summer and then somehow, over the years, that changed drastically. Maybe it was moving out of the hot city of Chicago to Maine, where summers are shorter. I'm not sure how, but these days I am a summer worshiper. I start my worshiping on the solstice and keep it going well into September, when the changing leaves force me to face the reality that autumn has arrived.

This year, as for the last several years, my sweetheart and I have spent the solstice week at a small rented cottage on the midcoast of Maine. Upon arrival, I always make a summer bouquet for our table. I do this as a dedication to my late Grandma Vettese, who used to send me out wildflower picking before dinner at her rural cottage in central Michigan.

After I have my bouquet, we settle in with food and wine for our first long evening of light, which most every summer comes with incredible sunset colors. This summer, the solstice itself, June 21, brought rain. Sometimes that happens, of course, and that is just as beautiful. The green was even more vibrant the next day, so I added some new clippings to my bouquet. By mid-week, we were convinced that summer had finally arrived. We can see the moon and stars more clearly and everything around us seems to be overflowing with the promise that comes along with the warmth, brightness, and sweet new colors of summer.

Solstice Sun-Print Napkins

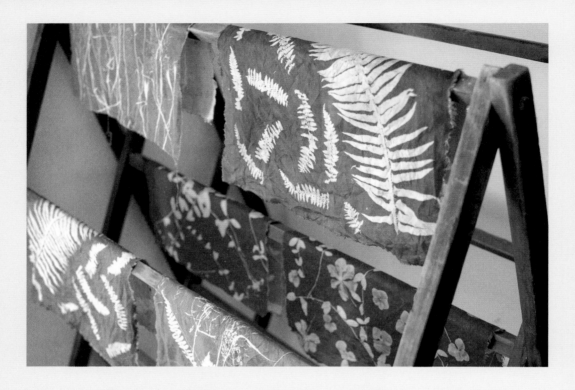

I celebrated the longest day of the year by making these napkins with my kids using a cyanotype fabric that reacts to light just like camera film. They mark in time the bright high sun of summer and the blooms that come with it, a great reminder on our tabletop come the dark days of December.

> 1 yard (90 cm) cotton cyanotype fabric that is 44 inches (112 cm) wide (I buy mine at blueprintsonfabric.com)
>
> Thoroughly dry leaves, trimmings, and flowers (see Note), for printing
>
> Scrap of cardboard larger than 14 × 14 inches (36 × 36 cm)
>
> Piece of clear glass or Plexiglas without UV blocking that is larger than 14 × 14 inches (36 × 36 cm) (I recommend using Plexi if you are doing this project with kids; ask for a piece at a frame shop)

NOTE: If your printing materials are not thoroughly dry, the moisture will leave splotches on fabric. They also need to lie flat underneath glass.

The cyanotype fabric reacts to any sustained light, so prepare your fabric indoors, away from direct sun. Return the fabric to the black plastic bag in which it arrived and seal with tape as soon as possible. One yard of fabric is enough for six 14-inch (36-cm) napkins. Take your fabric and measure 14 inches (36 cm) from the edge. Make a 1-inch (2.5-cm) snip with scissors and tear the fabric to make one long 14-inch (36-cm) strip. Measure 14 inches (36 cm) again, and tear to create a square and again to create another square. Repeat on the remainder of the fabric until you have six squares. You will be left with a few scraps.

Gather the materials you'd like to use to make sun prints. We chose items from our yard that were in bloom in June—hydrangea, ferns, and climbing vine, along with some weeds and grasses. Begin by doing a test print on one of the scraps, so you understand the process.

Working inside, away from direct sunlight, remove one of the napkins from the bag and lay it out on the cardboard, smoothing out any wrinkles and trimming away any loose threads. The fabric will be pale green at this point. Arrange the natural materials on the napkin to suit your fancy. Keep in mind that napkins are often displayed folded, so creating a design that reaches to the edges of the fabric will look best.

Gently place the glass over the top of the design, making sure everything is lying flat and there are no folds in the fabric. Being careful not to disturb your design, take the glass-covered cardboard outside and place it in full sun, away from any encroaching shade. Exposure time will vary depending on the strength of the sun. On the bright, sunny summer day that we made our napkins, we exposed them for about 10 minutes. On a cloudy day, 15 to 20 minutes may be needed. You will see the background fabric gradually change from green to a grayish blue. The longer the exposure, the deeper the blue will eventually be.

After exposed, remove the glass and the natural materials. Your design will be a yellowish green on the blue background. Immediately take the fabric to the sink and rinse under running water until the runoff is clear and the design changes to white. Hang the napkin or lay it flat to dry, inside, out of direct sunlight. Repeat the process with the remaining napkins. As the napkins dry, the blues will deepen and the design will sharpen. Once dry, press the napkins and create a fringe by pulling the threads around the edge until you have a 1/4-inch (6-mm) border. To launder the napkins, use a phosphate- and bleach-free detergent and hang to dry.

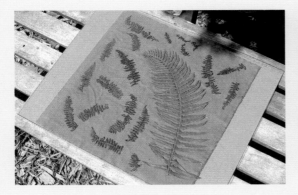
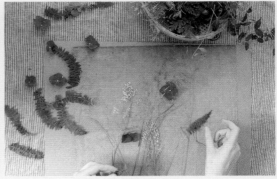

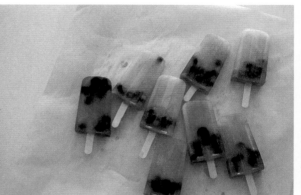

JULY

DEAR MAV,

Back in Oregon, but still dreaming of Maine. So much fun to visit and play neighbors for a week. That first day when you showed up at our back door felt surreal (I love seeing you pregnant, as fit and spry as I'd always imagined you'd be). Fussing around with the baby's tiny things in her room was a highlight for me. Unfair to have to leave you on the verge of giving birth! Our visit was all too brief. I wish we could have just one more meal together outside, lingering until darkness and mosquitos chase us inside.

We are having an exceptionally hot and dry summer, which makes me miss the foggy cliffs of Maine all the more! I am notoriously crabby in the heat, so it's been a challenge. Picnic dinners of salads and cold noodles help, as do sunrise walks up to Mount Tabor when the air is still cool. Everything is ripening early. I brought home a melon so ready and sweet, its perfume filled the entire house before we cut it open and ate it in one sitting with a couple of grapefruit spoons.

Anxiously awaiting news from you! Wishing you a happy and blessed birth!

LOVE,

SCB

DEAR SCB!

July is almost over and we are nearly ten days past the date that the baby was "due." I kept telling people that she would come in late July instead of saying July 19 specifically, but at the same time, on the inside I couldn't help but feel like the 19th was the day we would meet our new little one. It has been nice to have these extra, relaxing days at home as we wait and try to be patient. I have been enjoying catching up on some projects around the house and some correspondence I fell behind on this year.

 I finally got a bird feeder! I had been wanting one for ages. I went to a beautiful bird store in Freeport to find it this week. There has been a mourning dove around my house of late—she has been here on and off for years actually—that finally pushed me over the edge and convinced me to buy my feeder. Her daily calls are beautiful, and I wanted to offer her a thank you. The feeder is right outside my dining room window, so the cats and I plan to enjoy many good stares as we have our morning coffee.

 I can't believe my mom has been gone for just over ten weeks. There are days when I refuse to believe it is true, but then the phone does not ring or her emails don't come in and I know this is, indeed, my new reality. Still, I can close my eyes and talk to her in my mind and I often do. I hope that will continue forever because we have so much more to talk about.

 The next time I send you a letter, I will be a mom and I will have a family of three! Crazy! I am so lucky. So looking forward to sharing this journey with you, friend.

HUGS,

MAV

Carrot and Zucchini Bread

My farmer's market has an abundance of carrots and zucchini at this time of year. I love to buy a few of the very large zucchini, usually quite cheaply because they are not as desirable as the small ones, and keep them in the drawer in the refrigerator so I can make this loaf during a lull in these busy summer weeks. I almost always double the recipe and make one loaf to freeze or for a friend. **MAKES 1 LOAF (AND IS EASILY DOUBLED)**

1 cup (130 g) spelt flour
1 cup (125 g) all-purpose flour
2 teaspoons baking soda
1 teaspoon baking powder
1 teaspoon salt
1½ teaspoons ground cinnamon
½ teaspoon ground or freshly
 grated nutmeg
½ cup (100 g) sugar
¾ cup (180 ml) canola oil
½ cup (120 ml) pure maple syrup
½ cup (120 ml) unsweetened applesauce
2 large eggs
3 cups (330 g) grated carrots and zucchini
 (see Note)

NOTE: To prepare zucchini, grate it (in your food processor if you have one), pile it on a towel, and roll and wring out some of the water. Once drier (it might need two good wrings), put it into a bowl with the grated carrots.

Preheat the oven to 325°F (170°C). Grease a basic loaf pan or 9-inch (23-cm) square cake pan and set it aside.

Combine the flours, baking soda, baking powder, salt, cinnamon, and nutmeg in a bowl and set aside. In a standing mixer with a paddle attachment, beat the sugar, oil, and maple syrup until well combined, about 2 minutes. Add the applesauce and beat for another minute. Add the eggs and beat until well combined, about 2 minutes. Add the dry ingredients to the wet ingredients and mix very slowly until just combined. Fold in the carrots and zucchini gently.

Pour the batter into the prepared pan and bake for 50 to 60 minutes. Note: Be mindful with your baking time. This is a very moist bread and you don't want to underbake it accidentally. When done, a knife should come out completely clean of crumbs and the sides of the bread should be pulling away all the way around the pan. Let your bread cool in the pan for at least 30 minutes before slicing. The bread can be kept in the pan for storage, covered with a towel or plastic wrap.

Summer Vegetable and Chicken Hand Pies

One of the perks of playing neighbors with MAV on my visit was being able to fill her freezer with meals to eat after the baby's arrival. The individual pies can be frozen on the cookie sheet either before or after baking, then placed between layers of parchment paper in an airtight container or freezer bag. The pastry part of the recipe is adapted from Lucinda Scala Quinn's book *Mad Hungry*. **MAKES 10 HAND PIES**

2	tablespoons unsalted butter
1	leek, trimmed, diced, and washed (about ½ cup/45 g)
1	medium zucchini, diced (about ½ cup/55 g)
1	ear corn, kernels shaved off with a sharp knife (about ½ cup/75 g kernels)
1	tablespoon fresh thyme leaves
½	teaspoon coarse salt
2	tablespoons all-purpose flour
1	cup (240 ml) dry white wine or chicken broth
2	tablespoons heavy cream
1	heaping cup (220 g) shredded roast chicken
¼	cup (25 g) grated Parmesan cheese
1	recipe Cream Cheese Pastry (see below)
1	large egg, for egg wash

To make filling, melt butter in skillet and add leeks, zucchini, corn, and thyme. Sauté over medium heat for 5 minutes or until vegetables are soft and fragrant. Stir in salt and flour and cook for another minute. Slowly add wine or broth and stir until thickened, a few minutes. Stir in cream and Parmesan cheese, then fold in chicken. Cool in fridge.

Preheat oven to 375°F (190°C). Roll out dough in two batches and cut out ten 5-inch (10 cm) rounds total (I use a small plate as a guide). Place ¼ cup (55 g) filling on half of each circle. Working with one pie at a time, moisten edges of each dough round with water and fold dough over to form a half circle. Crimp edges with a fork.

Place pies on a parchment-lined baking sheet and chill in the refrigerator for a few minutes. Prick pie tops with a fork. Beat egg with a tablespoon of water. Brush tops with egg wash. Bake for 20 to 25 minutes, until lightly browned. Cool on baking sheet for 5 minutes before serving.

CREAM CHEESE PASTRY

½	cup (1 stick/115 g) unsalted butter, at room temperature
4	ounces cream cheese, at room temperature
¼	cup (60 ml) heavy cream
1½	cups plus 2 tablespoons (205 g) all-purpose flour
½	teaspoon salt

Combine butter, cream cheese, and cream in food processor and process until thoroughly combined. Add flour and salt and process until combined and a ball forms. Divide dough into two disks and wrap in plastic. Refrigerate for at least 30 minutes before rolling out.

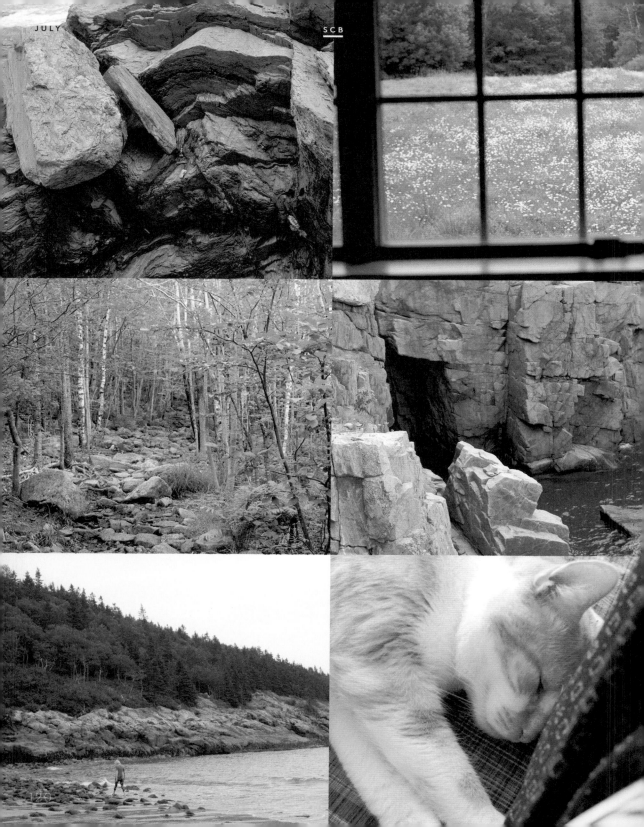

A REUNION IN MAINE

I have been traveling the 3191 miles to Maine yearly since MAV and I began working together in 2007, but I have never had the opportunity to share Maine with my kids until this summer when we visited for a family vacation. We rented a historic home walking distance from MAV where we cooked big meals, lazed in the backyard hammock, and watched Fourth of July fireworks from the rooftop deck. Seeing the sweet nursery at MAV's and giving her a hug after all these months felt so good.

The hum of Maine takes on a busy tenor in the summer months, but we enjoyed being part of the tourist crowd, staking a claim with our towels and beach chairs along the sea grass at Crescent Beach and waiting in long lines for lobster rolls at Two Lights Park.

We ended our trip with a drive up the coast to Acadia National Park and Mount Desert Island. It was my first time in this part of Maine, and I was overwhelmed by the dramatic beauty of the park and charmed by the gardens and communities that dot the island. On our last day, we ended our hike with one final beach visit, and I turned to see my teens jumping in the waves fully clothed. Freedom that only vacation brings.

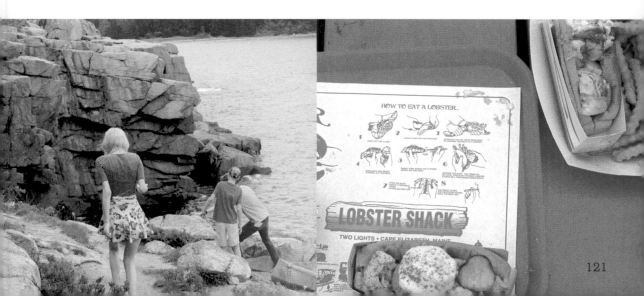

Minimal Mobile

When MAV and I were zero miles apart, I wanted to work together on a project that she could talk about and share with her child in years to come. My goal was to create something that wouldn't take too long and that would be in keeping with the sophisticated and effortless style of MAV's nursery. We decided to make a mobile with some treasures from MAV's collections.

Brass rod, ⅛ inch (3 mm) in diameter, 12 inches (30 cm) long (we found the rod at the
 hardware store and had an employee cut it to our desired length)
Clear fishing line
Found items, such as shells, wood, feathers, beads, trinkets, ribbon, and paper scraps
Super Glue

Place the items you have collected on your work surface, playing with colors, shapes, and textures until you are happy with your combination. Keep it simple! Sticks or pieces of driftwood can add another layer to your mobile, or everything can just cascade down from the brass rod. MAV chose a shell and driftwood from a favorite beach, a piece of rose quartz (a symbol of unconditional love) that was a gift from her mom, and a ceramic bead and telescope lens (both gifts from artist friends).

Assembling the mobile takes patience. It's best to work with a friend who can help you hold things in place as you go. Start by tying a length of fishing line at the center of the rod in a secure square knot. Make it long enough to attach to a hook in the ceiling or wall at the height you'd like to hang the mobile. We chose to string a bead and knot it in place here as well. Continue to tie lengths of line and attach objects, sliding the knots back and forth on the line like a seesaw or scale to achieve the right balance (so the rod remains horizontal when hung). Once you have your placement right, secure each knot with a dab of glue. Hang.

Grilled Corn with Chili and Lime

Plump, fresh summer corn needs little preparation, but I like to add a bit of spice and acidity to balance out the sweetness. I have always grilled corn directly on the grill, free of husk or foil. That bit of char on the kernels is the taste of summer BBQs to me.

Fresh corn (one ear per person)
Olive oil
Coarse salt
Chili powder
Fresh limes

Shuck and clean the corn, removing all traces of silk. Snap each ear in half (because it is easier to move smaller pieces around the grill). Place the corn in a large bowl, drizzle with olive oil, and sprinkle lightly with coarse salt and chili powder, then use your hands to rub the seasoning mixture over the ears. Place the corn on a medium-hot grill. Turn ears every few minutes as the color deepens and brown and black spots form, cooking for 10 to 12 minutes total. Remove corn to a platter and top with a generous squeeze of lime.

Sunshine Tea

I drink this calming and refreshing tea warm and iced. It's lovely both ways. You can easily make a whole jug by roughly tripling the recipe. **MAKES 1 CUP**

1 teaspoon dried spearmint
 Tea sack (available in grocery stores)
2–3 sprigs fresh mint
1 (1-inch/2.5-cm) piece of fresh lemon peel
 Lemon wedge
 Honey, for sweetening

Put the dried spearmint in a tea sack. Combine all of your ingredients in a mug or glass mason jar, squeezing the lemon wedge to release its juice. Pour in enough hot water to fill your cup and at least 1 teaspoon honey, then cover and steep for a minimum of 10 minutes (the longer, the better). Discard the mint and spearmint. Drink warm or cool to room temperature, then add ice and drink cold.

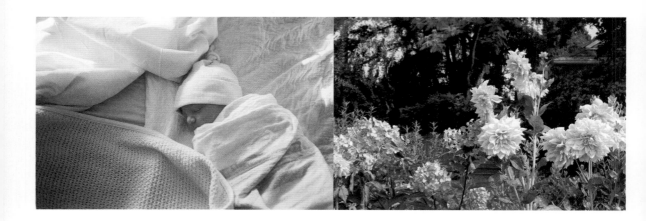

AUGUST

DEAR SCB!

Of course you know what I must start this letter with...the little addition to our family, Luna Rose Christine. She arrived on July 31 at 1:04 P.M. after 30 hours of very difficult labor. I will tell you this, when she came out, all I could do was laugh hysterically because I was absolutely beyond relieved that it was over! The labor was much more difficult than I had imagined and I am grateful, after all we went through, that she and I made it to the other side healthily and mostly happily.

LRC came home with us and moved confidently into her room. It was amazing. We laid her in her crib and told her, "This is where you live now," and she stayed there for two hours. Of course she has cried loudly quite a bit since, but she still continues to love being in her room. As a child I adored my bedroom so it makes me happy that she is already content in hers!

I have so enjoyed being home with her this month and am excited to have a big welcoming party for her on the 30th. This is a party I planned with my mom in lieu of a baby shower, so it will be especially important to all of us. I thought of you because I asked a small group of friends to make the desserts and I certainly wish you lived in Portland East so you could join in, too. Maybe you can make a treat for us when you come out this way again? One of your cheesecakes, your camping cookies, or perhaps one of your fruit crisps?

I hope you all are well as the kids get ready to head back to school and you get ready to have your work routine back. I know how much you enjoy the autumn and it's right around the corner!

LOTS OF LOVE,

MAV

DEAR MAV,

Welcome Luna Rose!! I am so proud of you, MAV, and know your mom would be, too! You have entered motherhood with tremendous grace, strength, and resilience. I absolutely cannot wait to meet Luna and see you in your new role as mom. My advice is to just take it one day at a time. She will surprise you every day. Sending love and support. Do not forget about the pocket pies I left for you in the freezer!

August continues to be oppressively hot here. To be frank, I have been feeling anxious for the summer to end. The initial sense of freedom and intimacy that summer vacation brought has since worn off, and my teens seem to take up more and more space in the home. They have become impossibly huge with their long legs draped over the edges of the furniture, leaving a trail of smoothie cups and charger cords and discarded clothing in their wake.

I am still getting up early to go on a walk before the heat sets in. I tend to trudge along, head down, lost in thought, but this morning as I passed through an alleyway between two houses, something brought my gaze up. I was greeted by cascading grapes, ripe plums, and dripping blackberry vines intertwined in a bacchanal of overgrowth. It was colorful and abundant and a welcome change of perspective. I saw not just the beauty of summer, but the necessity. Things need to come to full fruit.

Here's to the wonderful abundance that this summer has brought us!

WITH LOVE,

SCB

PS I wish I could be at your celebration for Luna! I would bring cookies, as they would be the easiest treat for me to eat while holding Luna! I would not want to put down that baby to use a knife and fork.

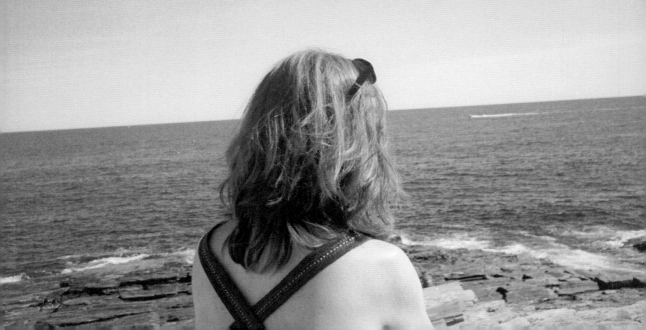

Sunflower Seed Pesto

I make this pesto every few days in August when my garden overflows with basil. I started using sunflower seeds as an economical replacement for pine nuts, but I have grown to prefer the earthiness they give to the sauce. Pesto tossed with fresh pasta is the easiest of summer dinners. In my family we also eat pesto spread on baguettes, on eggs, and thinned with additional fresh lemon juice as a salad dressing. **MAKES 1 CUP (240 ML)**

⅓ cup (45 g) roasted sunflower seeds
2 small or 1 large clove garlic
2 cups (100 g) loosely packed fresh
 basil leaves
⅓ cup (30 g) freshly grated Parmigiano-
 Reggiano cheese
½ cup (120 ml) extra-virgin olive oil
 Juice of ½ lemon (about 1 tablespoon)
 Salt and freshly ground pepper

Put the sunflower seeds and garlic in the bowl of a food processor. Pulse until it resembles a coarse meal. Add the basil leaves and cheese and pulse until the leaves are finely minced. With the processor running, add the olive oil in a steady stream, stopping to scrape the sides of the bowl with a silicone spatula as needed, until the pesto is uniformly blended. Stir in the lemon juice and season with salt and freshly ground pepper to taste. Store fresh pesto in the refrigerator for up to a week or freeze in small jars (frozen pesto will keep for 6 to 9 months).

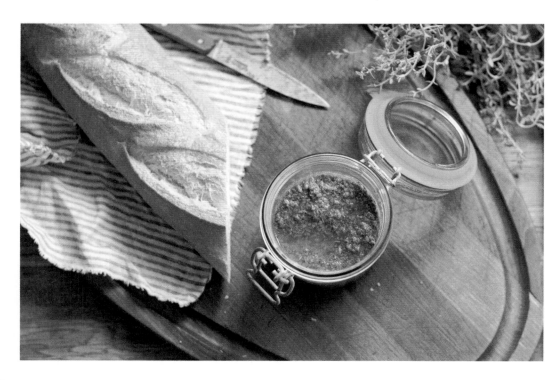

Quick Spiced Pickles

Always very intimidated by the prospect of traditional pickling, I was thrilled to learn this quick technique. It's perfect when the farmer's market is at its peak and fresh-off-the-farm cucumbers and carrots are aplenty.

MAKES TWO 1¹/₂-PINT (750-ML) JARS

3	cups (720 ml) water
1	cup (240 ml) apple cider vinegar
¹/₄	cup (50 g) sugar
1	teaspoon coriander seed (whole or ground)
1	tablespoon mustard seed
2	tablespoons black peppercorns
¹/₂	teaspoon crushed red pepper
¹/₄	teaspoon ground turmeric
¹/₂	cup (33g) kosher salt
¹/₂	cup loosely packed fresh dill
6	small pickling cucumbers
3	medium carrots

In a medium saucepan, bring the water, vinegar, sugar, coriander and mustard seeds, peppercorns, crushed red pepper, turmeric, salt, and dill to a boil. Stir well, reduce the heat, and simmer for 5 minutes. Remove the brine from the heat and let it cool for about 20 minutes.

Wash the cucumbers and slice them into thick rounds. Peel the carrots and cut them lengthwise into thin slabs. Pack the cucumbers and carrots into the two clean jars. When the brine has cooled, stir it well and pour it over the cucumbers and carrots, making sure to get an equal share of fresh dill into each jar. If there is a bit of space at the top of each jar, fill it with cold water. The jars should be filled to the top with liquid. Cool the contents of the open jars to room temperature and then screw on the lids tightly and refrigerate. Once the pickles are very cold, you can eat them up! They will keep for up to a week.

Summer Bounty: A Natural-Dye Project

This is a great way to capture and hold on to a bit of summer's magic. When the trees and flowers are in bloom, collect a few good handfuls of leaves, flowers, or berries to scatter over fabric. On this August day, I collected goldenrod and used it to dye a white T-shirt.

White cotton cloth to dye (the only limit is the size of your dye pot)

Natural elements (enough to scatter over your cloth), such as leaves, flowers, berries, or even onion skins

Twine

Stainless-steel tongs

Aluminum acetate (see Note)

Kitchen or postage scale

Large stainless-steel pot with lid

Stainless-steel steamer basket

Stovetop or hot plate

Long-handled stainless-steel spoon

Face mask from hardware store (optional)

Liquid thermometer (optional)

NOTE: We purchased our natural dye supplies from Long Ridge Farm (longridgefarm.com). Remember that pots and utensils used for dyeing can't be used for food. I suggest acquiring them from a thrift store, yard sale, or other inexpensive source and then labeling them clearly.

Prepare the cloth: Wash and dry the cloth and cut it, if necessary. Weigh your fabric: Our T-shirt weighed 5.75 ounces (163 g).

Calculate 5% of the weight of the cloth to determine how much aluminum acetate you will need. Aluminum acetate is a mordant (a substance used to set or enhance fabric dyes). For our 5.75 ounces (163 g) of fiber, we used .2875 ounce (8 g) aluminum acetate. (To calculate this quantity, we used a simple percentage equation: 5.75 x .05. You will replace the 5.75 with whatever your fabric weighs to find your ounce measurement.) Put on the face mask, if desired, or just be sure not to breathe deeply at this point. Put the quantity of aluminum acetate you calculated in a medium glass bowl and gently pour in enough hot water to dissolve it fully. Take your time with this step to ensure that you do not spill or breathe in the powder.

Transfer the alum solution to the large stainless-steel pot, then add the fabric and enough water to fully cover the fabric. Over low to medium heat on a stovetop or hot plate, heat the water until it reaches about 100°F (38°C) and keep it at a consistent temperature for about an hour, stirring the fabric every 10 minutes to ensure that the alum is distributed evenly. Take care not to let the water get too hot; you do not want it to boil or even simmer.

When the hour is up, pour the pot of water and the fabric into a strainer and let the fabric cool a bit. Once cooled, give the fabric a quick rinse in warm water. If you want to wait until the next day to complete your dye project, you can keep the wet fabric in a zip-tight plastic bag overnight. If you are ready to proceed, leave the fabric in the strainer and prepare your natural elements.

Prepare the cloth bundle: Break up your natural elements so they are small enough to be scattered over the cloth. Lay your fabric flat and place the natural elements on top. They can be scattered randomly or uniformly. Roll up the fabric tightly, including the sleeves if you are doing a tee, and fold it so the bundle is small enough to fit in your steamer basket. Bind the bundle with twine.

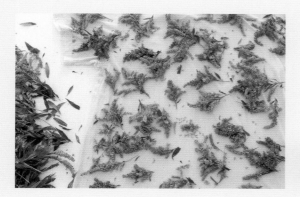

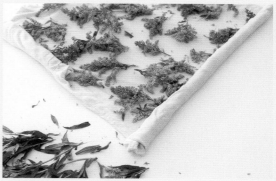

Prepare the steaming pot: Add water to your pot until the water level rises just below your steamer basket. Over medium heat, with the lid on, warm the water just until there is steam in the pot. Reduce the heat so the water temperature stays just below a simmer but continues to give off steam throughout the dyeing process.

Dye the cloth: Add the cloth bundle to the pot so it lays on top or inside of the steamer basket. If you want to dye more than one bundle in your steaming pot at the same time, make sure the bundles are not touching or the colors will mingle together. Cover the pot with the lid and steam

for 60 to 90 minutes, using your tongs to flip the bundle over halfway through and checking periodically to make sure the water does not come to a simmer or boil. When done, remove the bundle with the tongs and set aside to cool completely. Leave the bundle intact as it cools.

Once cooled, cut the twine and unroll your bundle. Remove the natural elements and discard them. Hang your cloth to dry completely, then wash your cloth as you would wash other cotton cloth. Wash it alone the first time so that if there is any excess dye, it will not transfer onto other laundry.

RIVERSIDE

August marked the eighth year in a row that our family has traveled to the same spot on the Metolius River to camp for a week. Situated in the Oregon high desert, the air here is dry and scented with ponderosa pine and sage underbrush. A fine dust is kicked up with every step; our sandaled feet are brown before we even finish setting up our gear in our campsite.

When all the conveniences and distractions and personal devices of home are removed, the chores and rituals of camp life take on new meaning and frame the day. Gray sun-parched twigs are gathered for kindling and stacked in a log cabin formation in the fire pit. Pots of water are carried, sloshing down our legs, from the river to be boiled and used for washing up dishes and dirty faces. When the work is done, we are given the gift of idleness—card games are invented, structures are built from pinecones, and books are finished, then traded back and forth. We hike before the day gets too hot and jump into the glacial river when it does. My kids know every bend of the river—where it gets deep enough to form a swimming hole, where the logs are positioned for crossing safely to the other side.

Meals are always simple—hot dogs on sharpened sticks, big bowls of pasta, corn rubbed with olive oil and lime and cooked in its husk over the open fire. Some days we walk to the camp store for cold beer or an ice cream sandwich and a few minutes on Wi-Fi. When the sun goes down, it gets cold quickly. We pull on wool hats and burrow down in our sleeping bags. This riverside campsite is our own little corner of the world, and the best place we know to celebrate being a family.

SEPTEMBER

DEAR MAV,

I hope you are settling into a routine with Luna and enjoying the final weeks of summer. Maine is so lovely in September. Remember my visit last year? Both my babies came in the fall/winter months and a large portion of our days were spent bundling and unbundling them or simply staying indoors. I imagine it must be wonderful to ease into your new life together with the freedom that warm weather brings.

We are back into our fall rhythm here—rising before the sun, breakfasting in distracted silence, packing bags with the day's lunches and snacks, and rummaging under the sofa for lost shoes before heading out by bus or bike or on foot to school and work. Despite grumbling at the morning alarm, the routine feels welcome, and back to school excitement lingers. The kids are still approaching their homework with vigor and interest. We'll see how long that lasts.

I couldn't wait any longer so I bought a ticket to Maine for next month! I can only get away for a few days, but I just have to meet Luna and give you a big hug. So excited.

LOVE,

SCB

DEAR SCB!

September has gone by so quickly! It has been the most beautiful month here. I always tell people, skip the high season and visit Maine in September. It's just the best.

We started out our month with guests, our nearest and dearest of friends, followed by a week away at the cottage. It has been a very full month, almost too full, and Luna Rose has been very fussy. You know how some babies are mellow? Well, this one is not. Luna is emotional, extremely aware and awake and in touch with what she wants and doesn't want. I love it! Don't let me mislead you—taking care of her and comforting her each day over the last eight weeks has been insanely difficult, but if someone said I could do it again, I would do it in a heartbeat. (I'd start just after I pushed her out on July 31st, mind you, as the idea of going through that labor again is not at all appealing.)

I am very excited that you bought your ticket to Maine. I can't wait to see you again. I have been craving a bit of travel myself. Did you know that I have not been on a plane in over a year? It is interesting how life really does move in chapters. I used to travel to several places each year and now I imagine I won't go anywhere again until next summer. I have felt very restless being at home so much of late, but at the same time taking daily rests with a new baby on my chest has filled up my heart. I also have a lot of time to daydream about my mom and that has helped me smile through the tears. I miss her so much. I was thinking the other day about how much I love being a mom to Luna Rose and how she must have felt this same way about me.

Happy autumn, dear friend.

HUGS!

MAV

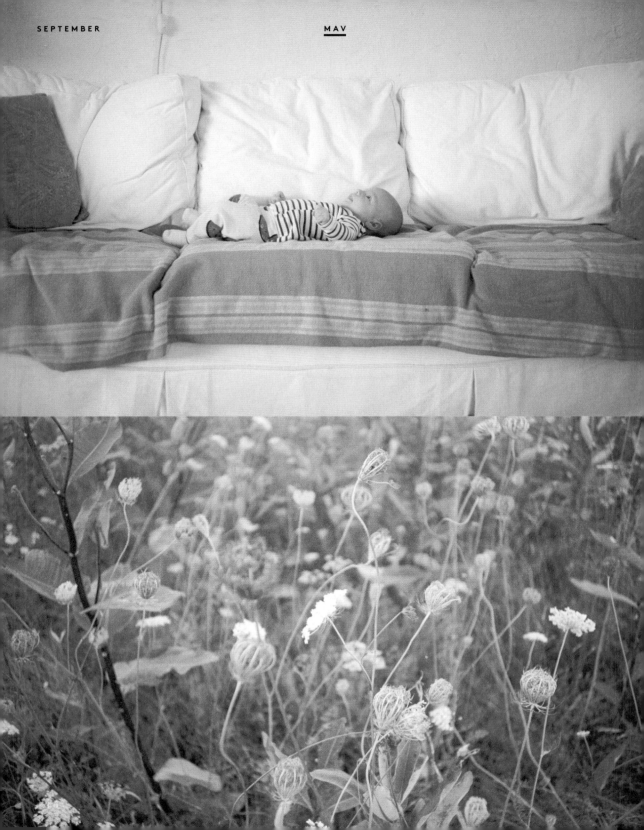

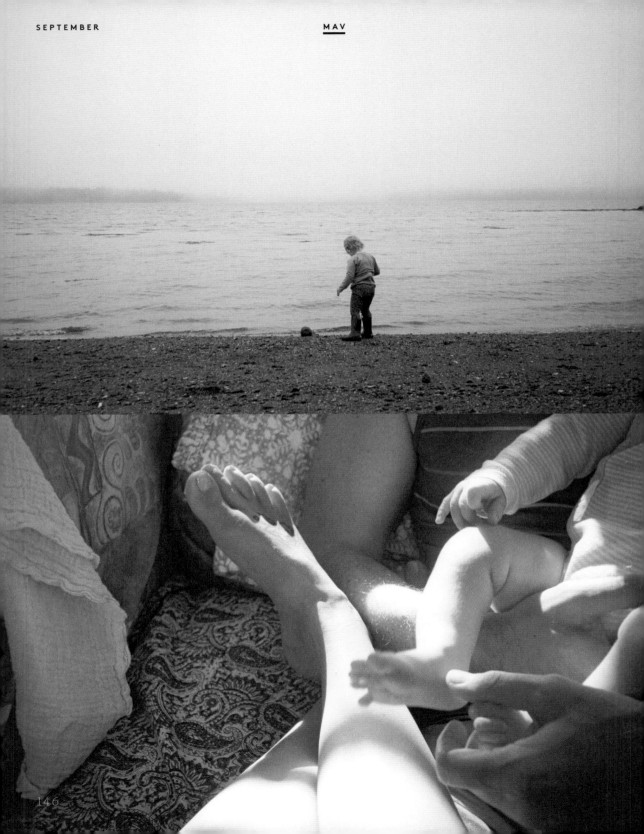

Standby Granola

I have been making this granola nearly every week since my children were tiny. On busy days it makes a quick breakfast with milk or yogurt, or it can be eaten as a snack by the handful whenever. The nuts, seeds, and dried fruit vary according to what I have on hand. In the summer months, when fresh fruit is plentiful, I leave out the dried fruit. **MAKES 5–6 CUPS**

3	cups (270 g) rolled oats
½	cup unsweetened shredded coconut
½	cup (150 g) nuts (pecans, almonds, or hazelnuts), chopped
½	cup (140 g) hulled seeds (sunflower, sesame, chia, or flax)
½	teaspoon ground cinnamon
½	cup (120 ml) brown rice syrup or maple syrup
¼	teaspoon salt
½	cup (140 g) dried fruit (cranberries, figs, dates, or apricots), diced if necessary

Preheat the oven to 325°F (165°C). Heat a large cast-iron or heavy-bottomed roasting pan over medium heat. Add the oats and toast, stirring for a few minutes. Add the coconut, nuts, seeds, and cinnamon, and continue to toast and stir for a few minutes more until everything begins to brown and become fragrant. Pour the syrup over the oats mixture and stir to thoroughly combine (as the syrup warms, it will be easier to combine with the oats). Sprinkle with salt.

Bake in the same pan for approximately 30 minutes, until slightly browned, stirring with a wooden spoon and checking for doneness every 10 minutes. Remove from the oven and stir in the dried fruit while still warm. Allow to cool in the pan. Store in an airtight jar for up to one month.

Peanut–Crispy Rice Bars

Super quick and easy to toss together for school lunches or after-school treats, these bars are a family favorite. Brown rice syrup is a healthier, less sweet alternative to corn syrup; it can be found at natural food stores.

MAKES 28 SMALL OR 15 LARGE SQUARES

²/₃ cup (165 ml) brown rice syrup
²/₃ cup (165 ml) natural peanut butter
 (or another nut butter like almond
 or cashew)
1 teaspoon vanilla extract
6 cups (180 g) crispy rice cereal
 (I use Erewhon's Rice Twice)
¹/₂ teaspoon kosher salt or other flake salt
 (optional)

Line an 11 × 7-inch (28 × 17-cm) baking pan with parchment so the parchment hangs over the short sides.

In a small saucepan, heat the rice syrup, peanut butter, and vanilla over low heat, stirring constantly, until blended and liquefied (a few minutes). Immediately combine the peanut butter mixture with the rice cereal in a large mixing bowl, then toss until the cereal is very well coated. Pour the mixture into the prepared pan, spreading it out to create an even layer and pressing gently into all the corners. Sprinkle the top with the salt if desired. Allow to cool in the refrigerator for 15 to 30 minutes. When cool and firm, lift out of the pan by the parchment and slice with a serrated knife (I do small squares for sharing and larger ones for school lunches). Store in an airtight container in a cool place or in the refrigerator for up to one week.

Waxed Cloth Wrap

A reusable alternative to plastic wrap and bags, these wax-coated cloths are perfect for packing lunches or storing leftovers. They are also a great way to use leftover beeswax from making spoon oil (page 28) and linen scraps from the selvage pillowcases (page 153). I like pure linen best, but woven cotton works as well. MAKES FOUR WRAPS: ONE 14 INCHES/36 CM, ONE 11 INCHES/28 CM, ONE 8 INCHES/20 CM, AND ONE 4 INCHES/10 CM

1/2 yard (46 cm) linen or cotton fabric (preferably organic)

Parchment paper

4 ounces (116 g) beeswax, grated or in pastille form

1 pint-size (480-ml) glass jar

Old towel

Small sponge brush

Iron

Wash the fabric in hot water and press. Cut into squares in the desired sizes. My favorite sizes are 14 inches/36 cm (covers my bread bowl for a rise or a salad bowl to take to a potluck or wraps up a half-finished boule), 11 inches/28 cm (perfect as a sandwich wrap or for a block of cheese), 8 inches/20 cm (to wrap a piece of fruit or leftover cheese), and 4 inches/10 cm (to cover a jar or

a small bowl). If you like, fray fabric edges by loosening threads along each edge with the point of a seam ripper or a needle and pulling them away with your fingers. Cut pieces of parchment that are 4 to 5 inches (10 to 12 cm) larger than the cloths, two for each piece of cloth.

Place the beeswax in the jar and put the jar in a pan of gently simmering water. Stir with a chopstick until wax has completely melted into a clear yellow liquid. While the wax melts, prepare a heat-resistant work surface. Cover the surface with an old towel. Place a piece of parchment on the towel and place the cloth square on top of the parchment. Next to the towel, spread out a large piece of parchment for drying the cloths. Bring the saucepan with the jar of melted wax to work area. Working quickly, use sponge brush to paint beeswax onto cloth until it is fully saturated. Do not fret if it looks messy or uneven, it will be fixed in the next step.

Heat iron to highest setting. Place another piece of parchment over your beeswax-soaked cloth. Press with hot iron, starting in the middle of the cloth and moving outward, pushing excess wax out of cloth and to the sides of the parchment. The cloth should look smooth and evenly saturated through the parchment. Quickly remove top sheet of parchment and move cloth to the drying parchment to cool. (It will be hot!) Repeat process with fresh parchment for remaining cloths, rewarming wax on stovetop as necessary.

Once cloths have cooled, they should be stiff but malleable, with no visible chunks of beeswax. If a cloth is too stiff or has visible layers or splotches of beeswax, press it again under fresh parchment.

When wrapping food in cloths, use the warmth of your fingers to create a seal. When needed, wash with dish soap under cool water (hot water will melt the beeswax!). Hang to dry.

Sugar and Spice Chai Tea

I usually make this warming chai with rooibos, a red, caffeine-free, calcium-rich tea with a nutty flavor. This year, however, with a new baby in the house, I need all the caffeine I can get! Note: This recipe uses cacao not cocoa.

MAKES 2 CUPS (480 ML)

1^{3}/$_{4}$	cups (420 ml) water
3	whole star anise pods
2	cinnamon sticks
10	whole cloves
10	cardamom pods
3	black peppercorns
1	(1-inch/2.5-cm) knob fresh ginger
1	cup milk (I use unsweetened almond milk)
1	teaspoon raw cacao powder
2	black or rooibos teabags
2–3	teaspoons honey, for sweetening

Pour the water into a small saucepan. Add the anise, cinnamon, cloves, cardamom, peppercorns, and ginger. Bring the ingredients to a boil over high heat and then reduce the heat to medium and simmer for 10 minutes. Pour in the milk and add the cacao powder. Reduce the heat to low and stir with a spoon or whisk until the cacao is completely blended. Leave the milk mixture on low heat, barely simmering, for 5 minutes, stirring about once every minute. Turn off the heat. Drop a teabag and 1 to 1½ teaspoons honey into two mugs. Pour the hot milk mixture into the mugs through a fine strainer, reserving the cinnamon sticks and placing one in each mug. Stir. Cover the mugs and let the tea steep for 5 minutes, then remove the teabags. Use your cinnamon stick to stir the chai as you sip it slowly.

Linen Selvage Pillowcase

I love selvages—the self-finished edges of woven yardage that often feature contrasting threads—and found a way to feature them in these linen pillowcases. Each easy-to-sew case is finished with French seams, which makes them sturdy and durable for frequent washings. If you can't find linen wide enough, or if you prefer the feel of cotton, shirtings are a great option.

MAKES ONE PILLOWCASE

$^2/_3$ yard (60 cm) linen, chambray, or cotton fabric that features a unique
 selvage and is 58–60 inches (147–152 cm) wide
Coordinating or contrasting thread (I used contrasting thread here because
 I wanted my stitches to be visible)

Wash and dry your fabric in hot water as you would your sheets. Press. Cut a 23-inch (58 cm) length of fabric. Fold the fabric, right sides out, so the short ends (the selvages) meet at one end (if your fabric doesn't have an obvious right and wrong side, just pick a side to show). Pin along both long sides of the case. Machine-stitch a $^1/_4$-inch (6-mm) seam along each side.

Open up the case and press the seam over to one side (it doesn't matter which side). Turn the case inside out and press the seam flat. Sew a $^3/_8$-inch (1-cm) seam along each side, encasing the previous seam inside. Turn right side out, trim threads, and you have a sturdy case with no exposed seams or raw edges.

OCTOBER

HELLO, SCB!

Get ready for this . . . Luna is now nearly 24 inches long and just about 13 pounds! Can you believe it? She is so much bigger than I imagined she would be at nearly 12 weeks. I was a much smaller baby. My mom would be totally shocked, as she always said I was going to have a little peanut. We will have to see if she was born with some kind of tall gene that my sweetheart and I don't possess.

 I am getting ready for your visit next week and thinking we should take it really easy. Lately I have been rushing around a bit more than I like. Everyone around me is so busy at this time of year. While you are here, I'd like to relax with Luna, take some walks, take a road trip (just you and me), and cook some dinners. We can say good-bye to October together.

 I wonder how you are feeling about the approaching holidays? I know that you and I can both take on too much and it can be hard to find balance. I am feeling determined to be realistic with my time, energy, and resources. It will be a very different sort of season for me this year without my mom and with Luna Rose. Deep pain and happiness will each hold a spot on either end of my balance beam as I try to honor old traditions and start new ones. I keep thinking, who will take me out for my 40th birthday? My mom always took me to breakfast or lunch on my birthday, her smile beaming as she told me how much she loved me. She also always made signs and hung them around the house, "Happy Birthday, Angel Girl." Life has given me a lot to think about and try to understand this year. I am not sure what it all means or if I will ever know.

Looking forward to seeing you very soon!

LOVE,
MAV

DEAR MAV,

I am so excited to meet Luna! Of all the visits I've made to Maine to see you, I know this will be the most special and will also mark a new phase in our friendship as I get to witness you as a mom and welcome Luna into our 3191 family. In the early years of my visits east, it always felt like an escape from my life as a parent of small children. There were decadent dinners out with multiple bottles of wine, falling into bed knowing no one would need me early in the morning. Such luxury! But now that my own kids are busy teens, and the rhythm of my life has changed, I look forward to the slow-down a newborn brings (adorably demands!) and want nothing more from my visit than to hold Luna and support you.

 I am tightening my grip on autumn by not thinking ahead to the holidays just yet. I do not want October to end. It is my favorite time of year. We have been up to Mount Hood to pick apples and on hikes through Forest Park to see the changing leaves, but other October traditions, like pumpkin picking or planning Halloween costumes, are no longer part of our family life. I am learning that letting go of some traditions allows us to hold on to others and gives us space to create new ones.

 I welcome the encroaching darkness of October mornings and evenings. It is comforting to me. We light candles at breakfast and dinner now, but we still have not turned on the heat, climbing under wool blankets instead. After a long, hot, active summer, the shuttering and pulling in of our domestic lives feels so good.

LOVE,
SCB

Blue Spoon Bistro Burger with Warm Potato Salad

"I hate a greasy burger. And nobody likes a dry burger," my friend David Iovino told me when we got together on a bright autumn morning to make lunch. David owns Blue Spoon, a restaurant on "the hill" in the East End. Blue Spoon has been around since 2004. It's a cozy neighborhood spot that I've adored since moving to town shortly after it opened.

David says, "The caramelized onions and red wine in this recipe give the burger moisture. This way, you can use very lean beef. Also, we use A Wee Bit Farm for our organic grass-fed beef. This type of beef is typically more lean than industrial beef, so you get more flavor."

David also talked to me about the importance of a good bun. "A burger bun should have a bit of sweetness and softness. We slice it, spread some fat on it, and toast or grill the cut side only. Simple. Delicious!"

At Blue Spoon, condiments and toppings range from ketchup, mustard, and herbed aioli to lettuce, tomato, a fried egg, thick-cut bacon, confit, mushrooms, or David's mom's smoked slow-cooked sweet onions. David says, "Let your imagination roam. This burger is good with whatever toppings you like!" **MAKES 4 BURGERS**

½ small yellow onion
1–1½ tablespoons fat of your choice,
 such as olive oil, bacon fat, duck fat,
 or coconut oil
1 cup (240 ml) red wine
1⅓ pounds (605 g) lean ground organic beef,
 preferably grass-fed
1 teaspoon salt
½ teaspoon black pepper
4 toasted buns
 Your favorite toppings and condiments,
 for serving

Finely dice the onion. In a frying pan over medium heat, caramelize the onions in the fat, stirring occasionally just so the onions don't burn or stick, until they are a nice golden brown, 10 to 15 minutes. Pour in the red wine and reduce it until there is no liquid left. Set aside and let cool.

Once the onions are cooled, use your hands to gently mix them together with the ground beef and salt and pepper in a large bowl. Don't overwork the meat mixture because it will make for a tough and chewy burger. Divide the meat into four patties about ¾ to 1 inch (19 to 25 mm) thick. Use your finger to put a small dimple in the center of each patty. (This is so when it cooks, the burger will not contract and puff up into a ball but instead stay flat.) Grill or cook the patties in a cast-iron skillet to desired doneness. When using organic grass-fed beef, the burgers will be medium rare when they reach an internal temperature of 120°F (49°C).

Serve the burgers on toasted buns with your favorite toppings and condiments, and warm potato salad on the side.

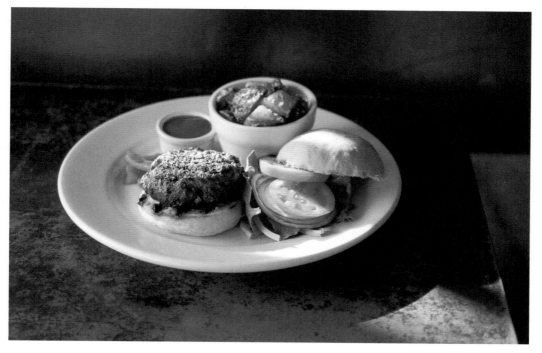

WARM POTATO SALAD

MAKES 4 SERVINGS

For the vinaigrette:
- ½ cup (120 ml) mayonnaise
- ½ cup (120 ml) whole-grain mustard
- 1 tablespoon Dijon mustard
- 2–3 tablespoons aged red wine vinegar
- ½ cup (25 g) loosely packed chopped fresh herbs (parsley, thyme, rosemary, or other herbs of your choice)

For the potatoes:
- 12 medium red potatoes
- 1 cup (60 g) coarse salt
- 2–3 tablespoons fat of your choice, such as olive oil, bacon fat, duck fat, or coconut oil

 Salt and black pepper

To make the vinaigrette, whisk together the mayonnaise, both mustards, the vinegar, and herbs in a mixing bowl. Set aside.

To make the potatoes, preheat the oven to 400°F (205°C). Wash the potatoes well and dry them; they will still be damp and that is good. Place the potatoes in a large mixing bowl. Using a wooden spoon or your hands, coat the potatoes with the coarsely ground salt. Spread the coated potatoes onto an ungreased baking sheet. Roast in the oven for 15 to 20 minutes or until the potatoes are fork tender; do not turn off the oven. Cool, then cut into bite-size quarters. Heat your fat in a large skillet and add the potatoes once the fat is warmed. Over medium-high heat, toss the mixture until the potatoes are a little golden. Transfer the skillet to the oven and roast for 5 to 10 minutes more, until the potatoes are crisp. Dump the crisped potatoes into a large mixing bowl. Add the vinaigrette and toss. Season with salt and pepper to taste. Serve right away.

CLEAR IT OUT

Let's get serious. Most of us have too much stuff. From personal experience, I can promise you that streamlining will change your life for the better.

WHY?

It creates more time in your day because you have less clutter to manage. It gives you more energy because you feel less overwhelmed by your possessions. And it opens more space for creativity and for those you love.

In my opinion, your bedroom closet and dresser are the best places to start because they fill up so easily. When you see less, you will be able to actually see and do more! You will love getting dressed in the morning (at least on the good days), and you will know that the clothing you have makes you look and feel good. Finally, you will be doing a good thing energetically and karmically by sharing your extras with those who might actually use them. I advise that you give your excess to a donation center and/or invite friends over and let them pick through your piles.

TAKE YOUR TIME

Do not rush a good clean-out. Give yourself anywhere from two to four hours, depending on how much you have. Know that you will finish in the time that you are allowing yourself. Know that you might feel bewildered once or even twice throughout the process but that you can do it. The key is to stay the course.

GET IT ALL OUT

Begin by emptying your drawers and closet. Get it all out. You may want to do the emptying one area at a time (maybe start with drawers and then tackle the closet), so you still have space to move in. It's very important that you remove every last piece of clothing: socks, undergarments, everything. You must look at each piece on its own and then categorize it into the appropriate pile.

ASK THE KEY QUESTIONS

For every item and category/stack (sweaters, basics, pants, socks, etc.), you'll want to quickly ask yourself these questions:

1. WHEN DID I WEAR THIS LAST?

Be honest. With the exception of pieces you keep for sentimental reasons, if it hasn't been worn in six months, get rid of it. I don't mean seasonal clothing, obviously, but rather those items that linger at the bottom of your drawers or back of your closet. Chances are, if you have not worn them in the last six months, you're never going to wear them again, and you are certainly not going to miss them.

2. DOES IT FIT WELL?

Be prepared to try things on. Don't save clothing that doesn't fit. Whether it's the pants you bought at a sale because you figured you'd fit into

a size eight someday or the button-down shirt that pulls open, if it doesn't fit, it goes. Clothes that fit the way you want them to make you feel like you. Why wear anything else?

3. IS IT USEFUL TO ME?

Be discerning and identify the basics that you really need. To me, basics are T-shirts (long and short-sleeved) and tank tops. I keep a good stash in both cotton and wool because I live in Maine and tend to wear layers often. Save only the pieces that are in good shape and are the most useful. The rest can go in the rag pile, unless they can be worn by someone else.

4. DO I LOVE IT?

If your gut says yes right away when you hold up an item, then you know it's something that makes you feel and look good. If you're not sure, throw it in a "think it over" pile. Just be ready to make the tough choices soon.

MAKE PILES

Now that everything is out, and you're starting to ask the key questions, you'll want to create piles by category. My categories are giveaways, rags, off-season, must keep, and think it over. You can use whatever pile categories you like as long as you are organized about it.

Throw things on the floor if you want; don't worry about making a mess. Once everything is sorted, you can easily return to those items you are keeping and fold or hang them neatly.

BE RUTHLESS

At the end, you will need to go back through your "think it over" pile and decide whether having these things hanging around makes any sense. Is it a fancy dress from a wedding you were in four years ago? Is it a stained college T-shirt? Keep only the things that you wear, that fit well, that are useful, and that you love. Letting go of old pieces can be hard, but it is necessary and quite freeing!

NOW DOESN'T THAT FEEL GOOD?

Once you have everything put away, the piles have been cleaned up, and things are calm and collected in your bedroom, settle in and enjoy.

Root Vegetable and Apple Hash

The recipe for this hash was born from an overabundance of root vegetables in my fall CSA delivery a few years back (and an accompanying duo of finicky eaters). The apple lends a nice tart surprise to the earthy flavor of the vegetables. Top this hash with the traditional fried or poached egg or serve it with grilled sausages for a hearty fall meal. I like to use more or less equal quantities of each root vegetable, but the recipe is flexible—you can play with the proportions as long as the total quantity of vegetables is around 4½ cups (610 g). **MAKES 4 SERVINGS**

2	tablespoons coconut oil
1	apple, peeled, cored, and diced
2	carrots, peeled and diced
1	large or 2 small parsnips, peeled and diced
1	russet potato, peeled and diced
1	sweet potato, peeled and diced
1	small bulb of fennel, trimmed and diced
1	teaspoon kosher salt
½	teaspoon black pepper

Preheat the oven to 400°F (205°C).

In a large cast-iron or other heavy-bottomed roasting pan, melt the coconut oil in the oven until the oil has liquefied, about 5 minutes. Remove the pan from the oven and add the apple, carrots, parsnips, potato, sweet potato, and fennel to the oil; toss until the vegetables are evenly coated with the oil. Season with the salt and pepper. Return to the oven and roast for 30 to 40 minutes, stirring every 10 minutes, until the vegetables are browned and crispy. Serve hot.

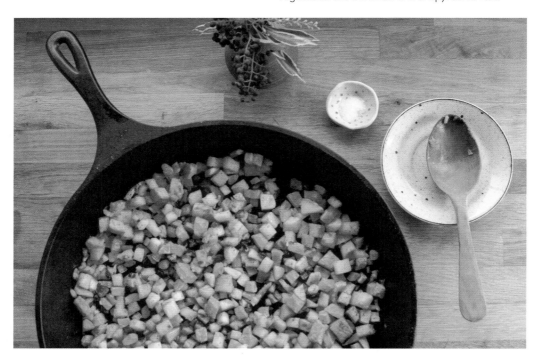

AUTUMN LIGHT

Noticing and watching the changing light in my small home feels like a meditation. It helps me slow down, honor the moment, and appreciate the beauty that is often all around me. It also helps me to mark time in a simple, meaningful way. When a certain light comes back, after having been gone for a year, it reminds me to reflect on all that has happened in that year. In winter, I get bright, clear sunrise light in my living room. In springtime, I see sweet, pristine white light in my kitchen. In summer, I notice hot stark sunset light in the back bedroom. In autumn, the most special lingering warm sunlight streams into every room. The light in autumn says, "I am going to idle just a bit longer so you can laze in my rays before I leave and hibernate for the winter."

ZERO MILES APART

It's rare that I make two trips to Maine in one year, but I had to return for a quick visit in October to meet Luna Rose. When I arrived from the airport, she was already in her early-evening slumber, swaddled up tight, her perfect round head peeking out. I was overwhelmed with love for this child and for her parents. Their little family makes me so happy. When she woke later, and I could hold her, I felt her true force—willful and bright and curious. Hello, Luna Rose!

MAV's home has long been a respite and sanctuary to me. She has created a serene, art-filled, comfortable environment in which it is a true pleasure to be a guest. I loved seeing the subtle changes she had made to accommodate and nurture Luna, as well as the small tributes, photos, and mementos of her beloved mom that she spread throughout the space. With just a few days to spend together, we decided to free ourselves of any agenda and just be together. We cooked simple meals and treats, ordered take-out, went on walks, and busied ourselves with the care and shared joy of Luna.

We did, however, go on one small adventure. Many years ago, on one of my very first visits to Maine, MAV brought me to Chase's Daily, a market and vegetarian restaurant a couple hours up the coast in Belfast. I was so charmed by the place that I have asked MAV to take me there every visit since. After a stunning drive lined by fall foliage, we shopped for baked goods and produce from the Chase family farm, and then met a dear friend, artist Jen Judd-McGee, for lunch. Three hours of conversation, and lots of laughter and tears later, we were still at our table and our server had to gently ask us to close out our tab. MAV and I have built a friendship over distance, but nothing compares to the time we spend zero miles apart.

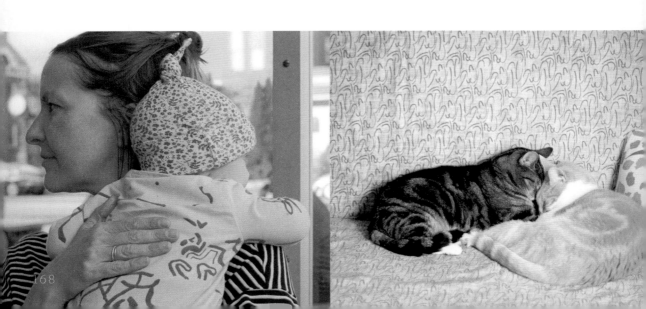

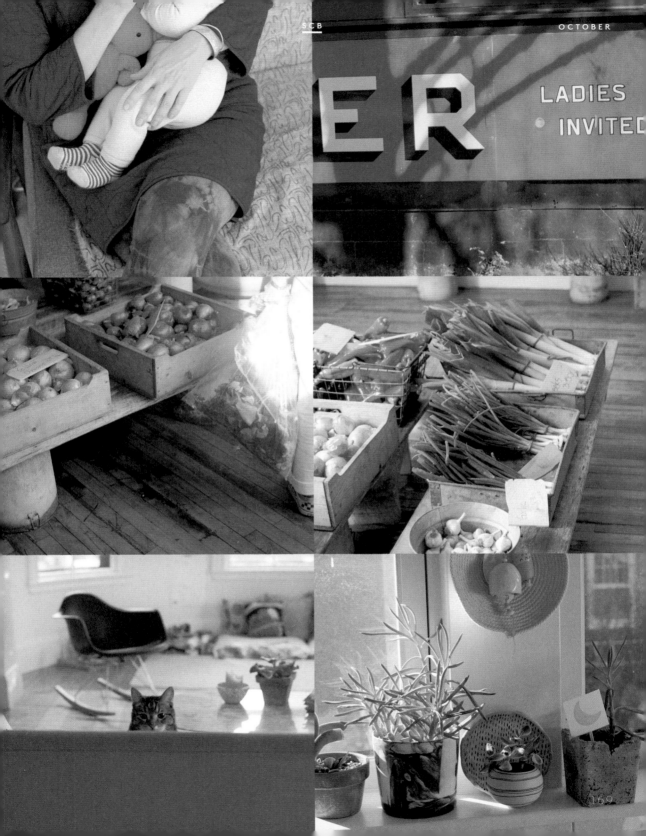

NOVEMBER

HELLO SCB!

As I look at my November calendar, I must admit I am feeling a bit intimidated. Thanksgiving is one of my favorite holidays and it is still weeks away, yet I already have this sense of being behind. We just had our annual "Thanksgiving meeting," where all of the friends who are going to be at our gathering come together to talk about the menu and other plans for the day. It was chaos, in the best of ways. It made me realize that with 13 adults and now seven children we are going to have our hands full. I was asked to make a cookie plate again. When am I going to ditch this cookie assignment and get back on the pie list? Don't my friends know I can make pie, too?

It will be interesting to see how Luna handles it all. She's showing a real shyness around people she doesn't know well. However, she loves watching a good conversation and occasionally joins in herself. It's very sweet. Did I tell you that we did a bit of "no cry" sleep training with her and now she is sleeping through the night? I actually think it has to do with her nature more than anything else. She has been a fan of nighttime sleep since the moment she came home from the hospital.

I have been thinking about how my mom would be clamoring for a sleepover if she were here. She was planning to keep a crib at her house so she could have Luna stay over a lot. That would have been so amazing. It makes my heart hurt. I remember how much I loved sleeping over at my Grandma Angelosanto's house when I was a kid. We would lie in twin beds next to each other and gossip late into the night. It was the best!

I know we will be in touch a lot as the holidays approach. May they be sparkling for us both.

XO,

MAV

HELLO MAV,

Happy Thanksgiving! For the first time in many years my entire extended family was able to celebrate together—my parents, my sister and her wife, my brother and his wife, my niece, Jack, and the kids. We pushed tables together at my sister's house and, in Congdon family tradition, piled our plates high with all the fixings. I didn't think I'd have room for dessert, but Miles made gingersnap ice cream in the ice-cream maker he got for his birthday last week, and I couldn't pass that up!

After dinner, I asked my kids what they were grateful for, and I received a shrug and an aggressive eye roll in response. It's a big question. I'm not sure I can put it into words either. I know I am grateful for all the leftovers in my fridge right now. I am grateful for a slow holiday weekend after a stressful few weeks of work. Tomorrow we'll drive out to a farm to cut down our Christmas tree, and I am grateful I'll get to visit with the sheep there!

While I love the evergreen scent of the tree in the house, I am not quite ready for the holidays. I think I'll string the lights, but leave the tree otherwise undecorated for a week or two or until the Christmas spirit strikes. I want to hold on to autumn for a bit longer even though most of the leaves have already fallen and our mornings are dark and icy cold. I am bracing myself for the busyness of December, but I do look forward to some jolly times. I will be thinking of you as you navigate remembering your mom while starting new traditions with Luna. I hope you have some jolly times, too.

ALL MY LOVE,

SCB

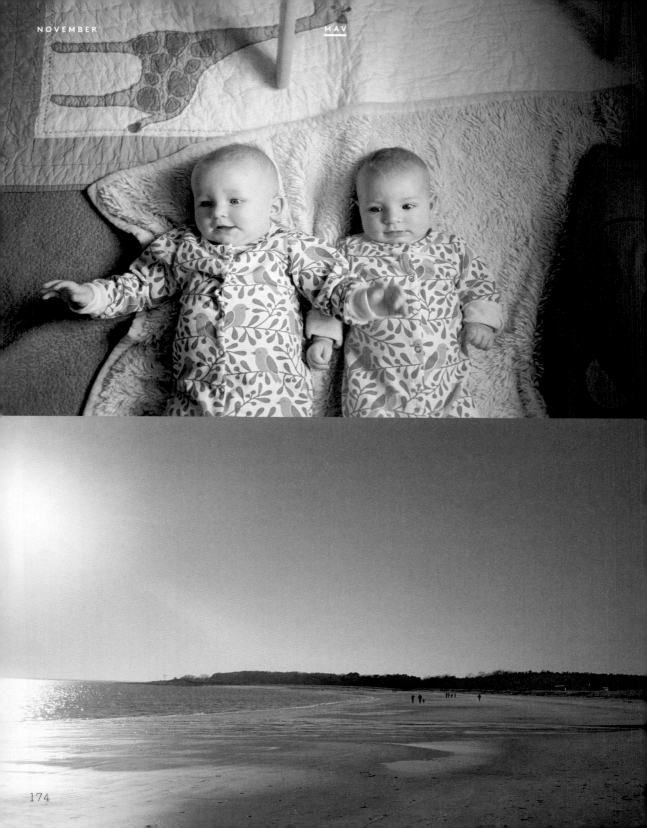

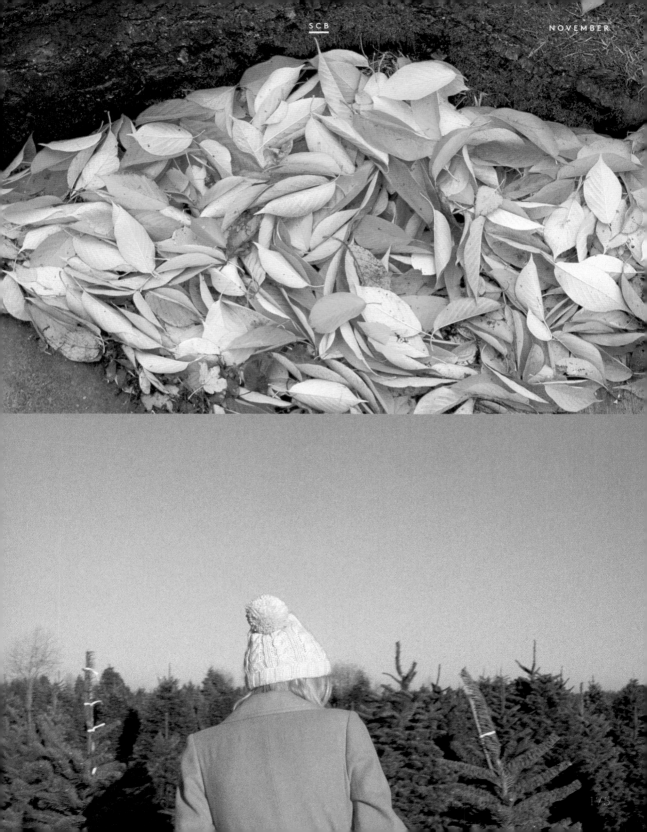

My Mom's Cranberry Sauce

Thanksgiving has long been my favorite holiday. Growing up I remember my mom cooking for days while I happily designed and set the table. The savory and sweet smells of Thanksgiving will always remind me of my mom and the magical memories she created for us.

When I moved to Maine in 2004 I started to celebrate Thanksgiving with friends instead of family. These gatherings are still going strong and are always spectacular. We usually focus on traditional fare, like this tried-and-true cranberry sauce, trying out just a few new dishes each year. I love watching the vibe change as we rotate houses and add little ones.

My mom was wild about this cranberry sauce. She always made her batch the night before it was going to be served, sometimes two nights before, saying that this helped the flavors shine. She often doubled the recipe to be sure there would be plenty of leftovers. My mom's secret tip, as she wrote on the recipe: "Serve the leftovers warm with vanilla ice cream; yum!"

MAKES ABOUT 4 CUPS (1 LITER)

1	small or medium orange (do not substitute a clementine)
2	cups water (480 ml)
1	tart apple, such as Granny Smith
3	cups fresh cranberries (285 g)
1	cup sugar (200 g)
½	teaspoon ground cinnamon
½	teaspoon ground cloves

Cut the orange in half. Squeeze the juice from the orange into a large pot and set aside. Remove and discard the membrane from the orange rind and dice the rind. In a small pan, bring the rind and the water to a boil over high heat. Reduce the heat to medium and cook gently for about 10 minutes. Drain the rind and drop it into the pot with the orange juice. Peel the apple, chop it into small cubes, and drop it into the pot. Sort the cranberries, getting rid of any that are soft to the touch. Add the good ones to the pot along with the sugar, cinnamon, and cloves.

Heat the cranberry mixture over medium-high heat, stirring every few minutes, until the cranberries start to burst and the liquid comes to a boil. Reduce the heat to low, partially cover the pot, and simmer gently, stirring every few minutes, until the sauce thickens and most of the cranberries have burst, about 15 minutes. Transfer to a bowl and serve immediately or refrigerate in an airtight container for up to 1 week. The sauce can be served hot, warm, or cold.

Sweet Potato Biscuits

Adapted from a recipe I found in an issue of *Martha Stewart Living* years ago, these sweet and buttery biscuits are always a hit with the extended family at Thanksgiving but are also a staple at my house year-round. I serve them with cranberry butter, which is just ¼ cup (60 ml) cranberry sauce blended in a food processor with ¼ cup (55 g) softened butter. I almost always double the recipe and freeze half the biscuit dough, cut out and arranged on parchment-lined trays then sealed in a freezer bag. On a night when I need something to go with a pot of soup, I can pull them out of the freezer and bake as few or as many as I need. **MAKES 18 SMALL BISCUITS**

1	pound (455 g) sweet potatoes or yams (1 large potato is usually sufficient)
2½	cups (315 g) all-purpose flour
4	teaspoons baking powder
2	tablespoons brown sugar
1	teaspoon salt
¼	teaspoon cayenne pepper
½	cup (1 stick/115 g) unsalted butter, chilled and cut into small pieces
¼	cup (60 ml) whole milk or cream

Preheat the oven to 400°F (205°C).

Prick the sweet potatoes with a fork and place them directly on a rack in the oven. Bake until soft to the touch, about 1 hour. Allow to cool completely. Slice the potatoes in half, scoop the flesh from the skin, and pass it through a food mill or potato ricer (or use a potato masher—you want a nice even mash, not a gummy puree). You should have about 2 scant cups (scant 480 ml) of mash. Stir together the flour, baking powder, brown sugar, salt, and cayenne. Cut in the butter with a pastry cutter (or use your fingers) until the mixture resembles a coarse meal. Mix the milk with the sweet potato mash and add it to the flour and butter mixture. Mix the dough, just to incorporate (I use my hands). If the dough is really sticky, add a touch more flour.

Turn out the dough onto a floured surface and knead a few times. Pat or roll it out into a ½-inch (12-mm) thick round. Cut out biscuits with a biscuit cutter or glass. I find that smaller biscuits cook more evenly, so I keep them around 2 inches (5 cm) in diameter (for Thanksgiving, I share my love with a heart-shaped cutter). Place the biscuits on a parchment-lined cookie sheet and refrigerate for 10 minutes. Bake until the biscuits rise and are slightly brown, 10 to 12 minutes (bake longer for larger or frozen biscuits). Serve warm.

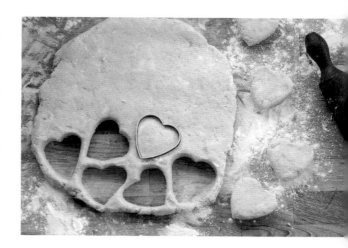

NOTES FROM THE NEWBORN DAYS

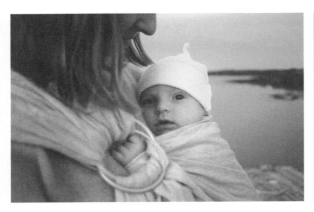

During the first 100 days with Luna Rose, I felt as if I were living in a wonderful, wacky haze. She needed essentially the same things day after day: sleep, snuggles, food, and diaper changes. I found I needed the same things every day as well: sleep, showers, fresh air, water, and a clean kitchen. Together, she and I (and her dad!) found a simple rhythm and got to know each other. I learned a lot in those early days about how to make things a little easier with baby.

There is no day or night clock; instead there is only a 24-hour clock.

I decided to take this approach with Luna Rose and it helped me tremendously. I was lucky that Luna seemed naturally inclined to being on a schedule, but I still needed to quickly accept that getting up at 2 A.M. or 4 A.M., or both, was just a fact of life. When I ceased to think of those times as "the middle of the night" and instead considered them to be "a few hours after I went to bed," I did a lot better with the whole concept. This small mind shift made a big difference for me.

Be as close as close can be.

Researchers have found that touch is the first sense to develop in babies. They have also found that touch (no matter our age) decreases our stress, bonds us to one another, and communicates what words can't. Although there were, of course, moments in the first 100 days when I just wanted to be alone, and physically free from Luna, her dad and I kept her close to us all the time except when she was sleeping in her crib. We always maintained close contact when we fed her, and she napped in our arms or in a carrier attached to our bodies. I will always remember these close early days.

Make everything comforting.

Since I knew I was going to be home way more than usual, and on a strange schedule, I set up cozy stations where I could comfortably hang out with Luna throughout the house. I made sure that each one made it easy for me to lie down or put my feet up, and I stocked them with diapers, wipes, and linens to wipe up messes, plus onesies, hats, blankets, and other things that Luna might need. This allowed me to move around the house and get little things done without pushing myself too hard. It was especially nice to have cozy spots set up for those nighttime. feedings.

Continue to do the things that make me feel like myself.

I quickly learned that having a newborn to care for takes up a lot of time. To combat that days-slipping-away feeling, I decided to make sure I was still doing at least some of the things that make me feel like me. So, I still walked to pick up a coffee. I still watered the outdoor plants. I still checked in at work. And on a more ambitious scale, Luna's dad and I still made our trip to the cottage in mid-September, but this time it was with a six-week-old Luna in tow. I incorporated her into my world and explained it to her along the way.

Don't compare.

It was certainly wonderful to talk to friends who had newborns at the same time, but I realized it was a waste of my precious new-mom energy to compare or judge our experiences. It took a few deep breaths before I could feel truly happy for the mom or dad whose ten-week-old was sleeping through the night or for the parents whose baby was happy to leave mom's or dad's arms to hang out with "strangers." I used every bit of willpower I had not to envy them or judge my own situation. I chose, instead, to look at what was happening for them as simply different. My baby is her own person and so is theirs and that is wonderful.

Autumn Luminaries: A Natural-Dye Project

These colorful luminaries, with their watercolor-like finish, can be used many times. Consider wrapping a set in twine and giving them, with tea lights, as a gift for a friend's front walkway or porch. MAKES 12 LUMINARIES

12 white paper lunch bags, each about 11 inches (28 cm) tall

Old towels

3 1/2–4 cups (840–960 ml) water

3–4 tablespoons color-inducing dried herb or spice (hibiscus, turmeric, saffron, paprika, rose hips, sumac, and calendula work well)

Tea lights

Cut off the top half of each bag, so they are roughly 5 to 5 1/2 inches (13 to 14 cm) tall. Lay old towels on a nearby table as a drying station. Bring the water to a boil in a saucepan, then turn off heat. Drop the herbs or spice into the water, cover, and let steep for 10 minutes. Uncover and dip or drop your bags, one at a time, into the dye, working quickly while the water is still hot (be careful not to burn your fingers), then remove and lay them out to dry on the towels. If a bag is completely submerged in the water, use tongs to gently grasp it and remove it from the dye, taking care that it does not tear. If the color begins to fade during the dyeing process, reheat the water to pull more color out of the herbs or spice.

Let bags dry completely. When you are ready to light luminaries, gently open each bag and center a tea light in the bottom. Make sure the bags are completely open at the top. If placing bags outside, pour sand or cat litter into them to weigh them down. Light your candles and enjoy the glow!

NOTE: I have never had one of these luminaries catch on fire, but obviously it is possible. Use your smarts and keep a close eye on them.

THE PERFECT TREE

We have been cutting down our Christmas tree every Thanksgiving weekend for many years now. Thanksgiving feels a little early, but every weekend in December feels a little busy, and it's nice to start the holiday season with one thing off our list. Longtime friends always join us at our favorite tree farm, which is also a sheep farm. A worker hands us a saw and a scrap of cardboard on which to kneel and points us toward the douglas firs (called "dougs" here) in one direction, the noble firs in another, and, still, grand firs in a third. In Oregon, we have a wealth of trees.

Our family used to argue quite a bit over which tree was the perfect one. One year there were even tears. Another year, the giant doug Mia and Miles insisted upon had to be trimmed down a foot to fit in the house. This year, we were more or less in agreement on a medium-sized noble within minutes, and the kids and I quickly moved on to drinking instant hot chocolate and feeding the sheep carrots from our palms while Jack strapped the tree to the top of the car. The sheep are my favorite part, including bringing home some lamb for a winter stew.

DECEMBER

SCB!

Hard to believe this is my last letter to you for the year! Of course, we both know I am happy to see this year come to a close, but I also feel a pang of heartache. I can barely recall a dull week and I really could have used one. As usual, your notes and photographs have helped keep me going. There were certainly days when I felt I couldn't recognize beauty in anything, but then I would view a snippet of something from 3191 miles away and it would jolt me out of my despair. I am ever so grateful to you for your friendship.

I have made my resolutions for the coming year, which include the usual "give more love," plus some new intentions, such as "listen to more music." I hope I don't start the year off putting too much pressure on myself. I need to remember that a new year doesn't necessarily mean a new me on day one. I think I will give myself January, and maybe even February, to sort of ease into my resolutions.

Luna Rose is almost 22 weeks old. It's incredible to see how much she has changed. Her favorite thing this week is talking to her stuffed animal friends. She babbles to them as she drifts off to sleep every night. It's so charming! People mention how having a baby changes you, but I feel a bit differently. It seems to me as if Luna has been with me forever, as if she has always been alive in my heart and in my mind, and it only took years for her to join me here in this world. It is so seamless to love and care for her. I am meant for this work.

I guess it is time to say one last good-bye to this year and hello to a new one. I wish you the very best of everything in the months ahead, dear friend.

Happy New Year!

ALL MY LOVE,

MAV

HAPPY NEW YEAR, MAV!!!

As I am rather neurotic, when we began to document our year back in January, I worried what calamities it might bring. How would we continue chronicling the simple moments through potential hardships or unexpected events? But when we lost your mom, followed so soon by the birth of Luna, I realized that the work we were doing was essential to surviving what life set before us. Your perseverance has been inspiring. I saw you take comfort in your routine and traditions, many of them passed to you by your mom, that you treasure. When small events in my own life left me feeling temporarily unmoored, I returned to documenting the light on the breakfast table or to hand-stitching a gift, finding my own place again.

Earlier this month, Mia turned 16, and I realized that our time together as a family before she leaves for college or other adventures is winding down. It is a bittersweet period: I am excited for my kids to head out on their own, and I relish the idea of Jack and I getting to live as a couple again, but I am also overcome with nostalgia for our family life. I was relieved this holiday when Mia and Miles insisted that we practice our usual traditions—the peppermint stick ice cream, the paper snowflakes, the sugar cookies shaped like pigs.

On the winter solstice, we set the table with the sun-print napkins that we made on the longest day of the year back in June. The bounty of summer, all the blooms and tall grasses, the bright sun and long days, felt so foreign, but only six months had passed. That abundance is just around the corner now. Thank you for helping me see that, MAV.

XO,

SCB

Standard Baking Company's Brown Butter–Pecan Shortbread

Standard Baking Company here in Portland East opened its doors in 1995, and has been known and appreciated worldwide for its lovingly crafted pastry and bread ever since. I have been fortunate to spend time getting to know the owners, Alison and Matt. I love that we are not only friends but also neighbors!

During some of our get-togethers Alison has been kind enough to bring me little tastes of recipes she is working on for the bakery. How lucky to be one of her tasters! This lovely shortbread was something I adored straightaway. Alison explains that "browning the butter deepens the caramel-like flavors. The inclusion of an egg yolk isn't traditional, but it helps add color to the shortbread." This recipe is easy to bake in big batches to share with friends at the holidays. **MAKES 4 DOZEN 1½-INCH (4-CM) COOKIES**

1 cup (2 sticks/225 g) unsalted butter, softened but still cool

½ cup (100 g) granulated sugar

¼ cup (55 g) lightly packed brown sugar

¼ teaspoon fine sea salt

1 large egg yolk

1 teaspoon vanilla extract

1 cup (125 g) all-purpose flour

1 cup (125 g) whole-wheat pastry flour or sifted whole-wheat flour

1 cup (120 g) chopped pecans (about 5 ounces/140 g)

To brown a portion of the butter, melt ¼ cup (½ stick/55 g) of the butter in small saucepan over medium to low heat. Continue to cook, swirling the pan a bit and watching closely to ensure that the butter browns evenly, until the butter stops sputtering and the foam decreases, 6 to 8 minutes. (The browner the butter, the deeper the flavor, but be careful not to let it burn.) Immediately transfer the browned butter, including any light-brown solid bits, to a small bowl. (Take care not to include the darkest bits at the very bottom of the saucepan.) Set aside to cool.

To make the dough, place the remaining ¾ cup (1½ sticks/170 g) butter in the bowl of a standing mixer fitted with the paddle attachment and beat until creamy. Add both sugars and the salt and continue to beat until light and fluffy. Add the egg yolk, vanilla, and the cooled browned butter and mix to combine. In a small bowl, whisk the flours together. Stir the flour mixture into the mixing bowl in 2 batches until well incorporated. Mix in the chopped nuts with your hands or a wooden spoon. Chill the batter for 20 to 30 minutes, until it's firm and easier to handle.

To shape the cookies, divide the dough into 4 pieces and roll each piece into a log shape, about 1½ inches (4 cm) in diameter. Wrap each log in plastic wrap, secure the ends, and roll it on the counter to compact the dough. Refrigerate until firm enough to slice, about 2 hours or up to several days. You can also freeze the rolls of dough for up to 3 months.

When you're ready to bake the cookies, preheat the oven to 325°F (165°C) and place a rack in the center of the oven. Line a baking sheet with parchment paper. Working with one log at a time, slice ⅓-inch (8-mm) thick rounds. Arrange the rounds about 1 inch (2.5 cm) apart on the prepared baking sheet. Bake each batch for 20 to 25 minutes, rotating the pan halfway through the baking time, until the cookies are nicely browned all over. Let cool on the pan for 10 minutes and then transfer to a wire rack to cool completely. The shortbread will keep for up to two weeks in an airtight container in the refrigerator. If you are going to eat them within a week, you can leave the container out.

Chocolate Stout Cake

I get a lot of requests for this recipe—I think that has a lot to do with the cream cheese frosting. Chocolate and stout make a very nice combination because they are both rich and earthy. This year I made the cake for the family Christmas Eve gathering at my brother's house and topped it with a beautiful ruby-red amaryllis. This cake is pleasing to both those who might like a plain chocolate cake (think: the little ones) and those who might have a more discerning palate (think: the big ones). **MAKES ONE 9-INCH (23-CM) ONE- OR TWO-LAYER CAKE**

14 tablespoons (195 g) unsalted butter, plus more for greasing
1 cup (240 ml) stout beer
3/4 cup (70 g) unsweetened cocoa powder
2 cups (250 g) whole-wheat pastry flour
1 cup (200 g) sugar
1 1/2 teaspoons baking soda
3/4 teaspoon salt
3 large eggs
1/2 cup (120 ml) sour cream
1/2 cup (120 ml) unsweetened applesauce
3/4 cup (180 ml) maple syrup
Cream Cheese Frosting (recipe at right)

Preheat the oven to 350°F (175°C). Generously grease a 9-inch (23-cm) tall round cake pan or two 9-inch (23-cm) round layer-cake pans.

Combine the butter and stout in a heavy saucepan over medium heat. Warm the mixture, stirring frequently, until the butter melts completely. Remove the pan from the heat and whisk in the cocoa powder until well combined. Set aside to cool to a warm room temperature.

Meanwhile, in a medium bowl, whisk together the flour, sugar, baking soda, and salt. In a large mixing bowl, beat together the eggs, sour cream, applesauce, and maple syrup until thoroughly combined. Add the cooled stout-cocoa mixture to the wet ingredients and stir to combine. Add the dry ingredients and mix well.

Pour the batter into the prepared cake pan(s). Bake the single tall cake for 60 to 70 minutes or the layer cakes for 30 to 40 minutes, just until a knife inserted in the center comes out clean. It's very important not to overbake this cake or it will become too dry; set a timer for the earlier end of the designated baking time, and if the cake is not done yet, check frequently until it is. Remove the cake from the oven and let stand for 5 minutes in the pan or pans. Carefully turn the cake out onto a wire rack and let cool completely before icing with the cream cheese frosting. The cake can be made one day before frosting. Wrap it in plastic and store at room temperature.

CREAM CHEESE FROSTING

MAKES ENOUGH FOR ONE 9-INCH
(23-CM) ONE- OR TWO-LAYER CAKE

2	(8-ounce/225-g) packages cream cheese, at room temperature
½	cup (1 stick/115 g) unsalted butter, at room temperature
¼–½	cup (60–120 ml) honey, depending on preferred sweetness
1	tablespoon confectioners' sugar
1	tablespoon pure vanilla extract

Combine all the ingredients in the bowl of a standing mixer. Whip everything at top speed until thoroughly combined and smooth. Use immediately or refrigerate in an airtight container for a few days; bring to room temperature before using to frost the cake.

Wool and Silk Pinecone

My fascination with the natural world led to my collection of pinecones, ranging from tiny alders to giant sequoias, gathered from the ground during my hikes all over the United States. Soon enough, I became determined to create a soft textile version and I have been making these pinecone ornaments for years.

As always, having the best materials and tools makes for the most satisfying crafting experience. It is essential that you use natural fabrics for your pinecone, as synthetics will not withstand the high heat of the iron needed for fusing the fabrics. I love using white wool, as it creates a snow-dusted pinecone effect, but you could choose other colors. An extra-strong thread and glover's needle will allow you to sew through the fused silk and wool pieces with ease. Take care, however, as the glover's needle is extremely sharp; a flexible thimble will protect your fingers and help you push the needle through. You can find the fusible web, glover's needle, and heavy-duty thread at most craft or fabric stores. MAKES ONE 4-INCH (10-CM) PINECONE

Photocopy of paper template (see page 201)

¼ yard (23 cm) white or cream wool (Coatings or Melton work best)

¼ yard (23 cm) 100% silk dupioni or taffeta in a contrasting color

Wool roving or other stuffing

½ yard (46 cm) ¼-inch (6-mm)-thick complementary ribbon (I used silk ribbon)

Double-stick fusible web, such as Steam-A-Seam 2 brand

Glover's needle (designed for sewing leather)

Thimble, such as the Clover brand leather coin thimble

Coordinating thread for machine-stitching

Coordinating heavy-duty thread for hand-stitching, such as Guterman extra-strong thread

Fine-pointed appliqué or embroidery scissors

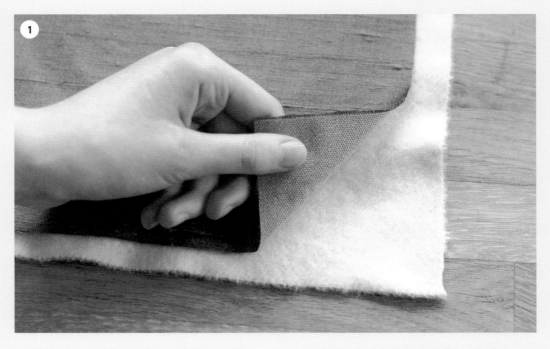

Cut three pinecone forms from the white wool. Match two of the pinecone forms together, wrong sides out, and machine-stitch with a ¼-inch (6-mm) seam allowance along one side between points A and B. Open the seam and match up the third body piece to each side and pin or baste to hold. Stitch along another side. Along the third

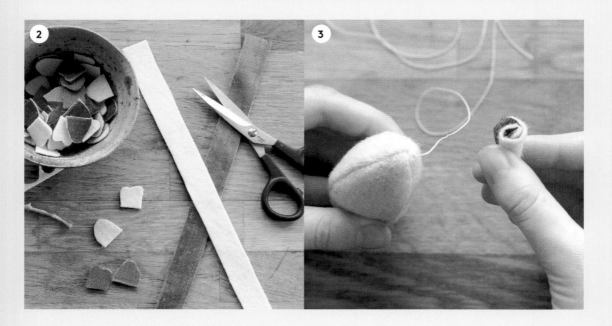

seam, stitch 1¼ inches (3 cm) down from the top and 1¼ inches (3 cm) up from the bottom, leaving a 1-inch (2.5-cm) opening. Turn right side out and stuff with the wool roving or stuffing, using a chopstick or pencil to ensure that the stuffing fills in the ends. Thread your glover's needle with the heavy-duty thread and use a blind stitch to close the opening, and then pull the thread up through the pointy end of your form (end B).

Press the silk fabric. Remove the backing of one 9 × 12-inch (23 × 31-cm) sheet of fusible web and place it squarely on the back side of the silk (see photo 1 on page 197). Trim away the silk not backed by the fusible web. Following the directions on the packaging of your fusible web, remove the second paper backing and place the fusible web-lined silk on the back side of the remaining wool yardage, smoothing out any wrinkles. Cover with a pressing cloth and press with a hot iron to adhere, ensuring that all parts of the fabric are fully fused. You should now have a sheet of wool backed in silk.

You will need 1 rosette petal, 4 bottom petals, and up to 75 body petals, approximately equal numbers of the two shapes provided in the patterns. The most efficient way to cut out the petals is to cut ¾-inch (2-cm) strips of the fused fabric with a straight edge and rotary cutter and then cut your body petals from those strips. You can use my pattern shapes as a guide for general shape and size, but I recommend cutting the petals freehand. Variations in the shape and details of your petals will help give your pinecone a natural look; just be sure to cut all the body petals approximately the same size. A pair of sharp scissors with pointy ends will make the fussy petal-cutting process easier (see photo 2 above).

To begin sewing on the petals, take your rosette piece and roll it up tightly (see photo 3 above). Secure it to the pointy end of your form where you drew the thread by piercing the bottom of the rosette with your needle and pulling the thread through all the layers of the rosette. Draw

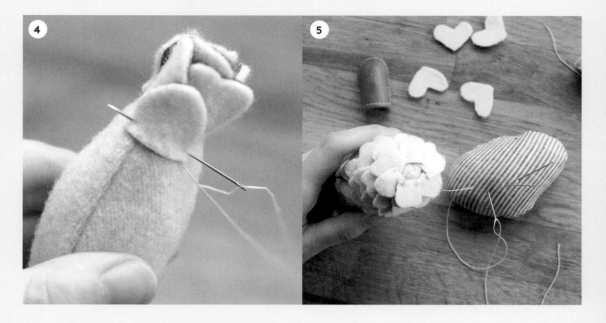

the needle through the other side of the rosette and into the pinecone form, anchoring the rosette tightly to the top of the form.

Now you are ready to begin the slow process of sewing on your petals one by one. Take a petal and place it about ¼ inch (6 mm) down from the top of the rosette. Secure it by drawing the needle through the bottom of the petal in one long stitch into the form and pulling the thread very tight. Layer another petal (I usually alternate the two shapes of petals) just slightly over the left side of the first petal and stitch again, making sure the needle first pierces the top petal, then the bottom petal, and fastens into the form. Continue this way until you have circled the rosette with petals.

Begin your next layer of petals by placing a petal in the center of two of the petals in the above layer, but about ¼ inch (6 mm) down, secure with the same stitching, and continue all the way around the form until it is time to move down

to a new layer (see photo 4 above). Continue adding the petals in this way, taking care that your layers of petals are relatively straight and knotting and replacing the thread as needed. Because each layer covers up the stitching on the previous layer, you do not need to be too fussy, but do be sure that you pull the stitches tight and that each petal is securely fastened to the form.

When your petals reach about ¼ inch (6 mm) from the bottom center of the form, switch to the bottom petals (see photo 5 above). Draw your needle and thread up from the center of the bottom of the form and down near the end of one of the bottom petals (at the V of the heart shape). Then draw the needle up near the edge of the left side of the petal, layer another petal on top, and make a small stitch to secure the petal (these are the only stitches that show, so take care with them), drawing the needle back up through the center of the bottom of the form. Repeat with the remaining bottom petals, tucking your last petal under the edge of your

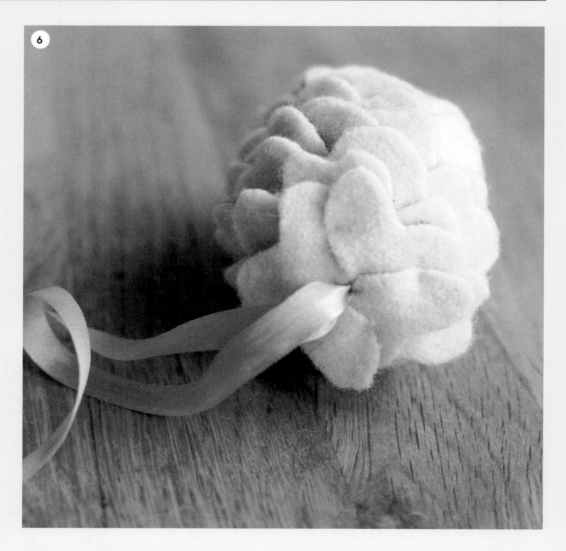

first bottom petal and drawing the needle and thread up through the center of the bottom of the form with your last stitch.

Cut a 16-inch (41-cm) length of ribbon, fold it in half and secure it at the center of the bottom of the pinecone with the needle and thread (see

photo 6 above). Pull the needle and thread out of the form underneath one of the petals and knot where it is hidden. Knot the top of the ribbon at the desired length for hanging and bevel the ribbon ends with scissors.

Pinecone Template

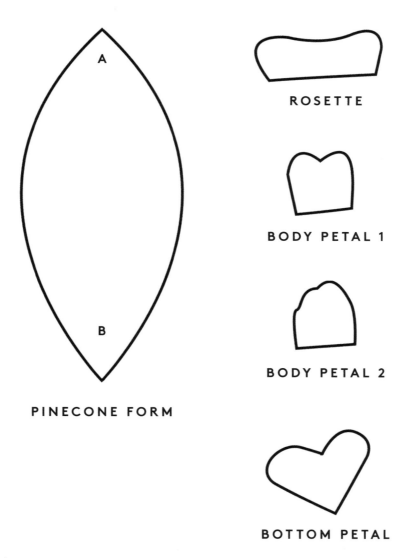

A

B

PINECONE FORM

ROSETTE

BODY PETAL 1

BODY PETAL 2

BOTTOM PETAL

Photocopy template at 100%.

Bunny Template

TOP (ATTACH TO HEAD)

BUNNY BODY

Photocopy template at 140% to enlarge to actual size.

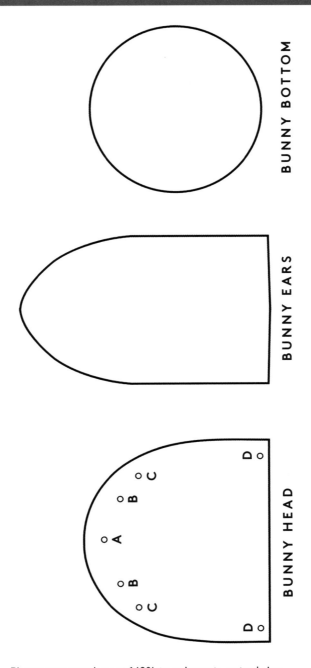

BUNNY BOTTOM

BUNNY EARS

BUNNY HEAD

Photocopy template at 140% to enlarge to actual size.

Index of Recipes and Crafts

ACKNOWLEDGMENTS

Gratitude to:

Our 3191 team, Chloe May Brown, Evan Twachtman, Ryan Shimala,
Martin Connelly, and Christopher Ryan

Our editor, Melanie Falick, and everyone at Abrams

Our book designer and friend, Deb Wood

The writer and our longtime friend, Molly Wizenberg

MAV's Portland East friends and chef/bakers, David Iovino,
Alison Pray, and Sonja Swanberg

MAV's film photography guru, Valerie Van Zandt

MAV's uncle, Ronald Santo

Our friend and collaborator, Lena Corwin

The longtime 3191 Miles Apart supporters

And finally, our dearest families as well as the cats,
Chester, Charlie, and Scotch

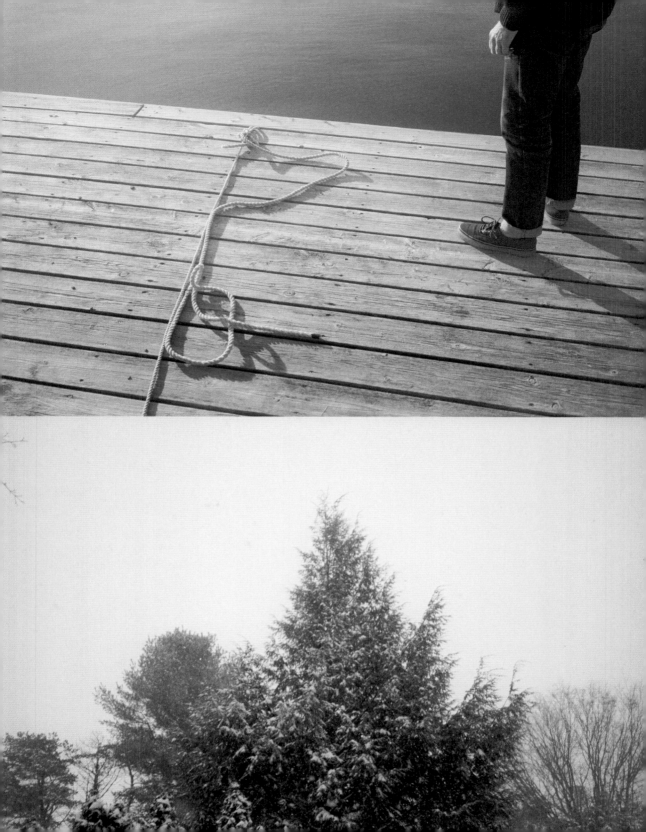

Editor: Melanie Falick
Designer: Deb Wood
Production Manager: Kathleen Gaffney

Library of Congress Control Number: 2015955483

ISBN: 978-1-4197-2246-2

Printed and bound in China

10 9 8 7 6 5 4 3 2 1

Abrams books are available at special
discounts when purchased in quantity for
premiums and promotions as well as fundraising
or educational use. Special editions can also
be created to specification. For details, contact
specialsales@abramsbooks.com or the address below.

ABRAMS The Art of Books
115 West 18th Street, New York, NY 10011
abramsbooks.com